ORNAMENTAL IRONWORK
OF CHARLESTON

EDITED BY WILLIAM P. BALDWIN

Charleston · London

THE
History
PRESS

Published by The History Press
Charleston, SC 29403
www.historypress.net

Copyright © 2007 by William P. Baldwin
All rights reserved

First published 2007
Second printing 2012

Manufactured in the United States

ISBN 978.1.59629.367.0

Library of Congress Cataloging-in-Publication Data

Ornamental ironwork of Charleston / edited by William P. Baldwin.
p. cm.
ISBN-13: 978-1-59629-367-0 (alk. paper) 1. Architectural ironwork--South
Carolina--Charleston. 2. Decorative cast-ironwork--South Carolina--Charleston.
I. Baldwin, William P.
NA3950.O76 2007
739.409757'915
2007038944

ACKNOWLEDGEMENTS

Thanks to Kirsty, Shawna and my friends at The History Press. Thanks to Elizabeth Turk, whose formula for editing photographs I continue to use, and thanks to Cheves Leland for driving me around Charleston and sharing her mother's ironwork notes.

Photographs on the following pages can be found in the Library of Congress's Historic American Buildings Survey and are largely the work of professional photographer Charles N. Bayless. The remaining ninety or so were taken by me between 2002 and 2007.

HABS photos on pages: 8, 9, 11–15, 18, 24–27, 30–31, 42–43, 48–49, 52, 55, 62–66, 68–72, 74, 80–81, 83–85, 87, 91–93, 98, 100, 102–103, 105, 107–112, 114–116, 121, 129–130, 132–133, 137–139, 141, 145–146, 148–149, 151, 153–154, 158–162, 167–175.

INTRODUCTION

This is a tour guide of sorts. The ironwork examples are listed (approximately) in the order you will come to them on the street. The streets are listed in alphabetical order. And so it is possible to go about the older portions of the city with book in hand and come away with some notion of the subtle (and at times unsubtle) way in which decorative ironwork enhances our enjoyment of Charleston's environs. A simple rectangle dwelling gains interest through the attachment of a single and equally simple balcony. A staid Federalist home is faced completely in fanciful Victorian intricacies. Lampposts and lamps, storefronts, boot scrapers, window grilles and signs—all are made of metal and all are contributing to the unique architectural experience that we know as Charleston. I've included a few bronze statues as well.

The earliest views of the city show balconies on many of the houses, but whether they are of wood or iron is impossible to say. By 1753, a blacksmith in the city was offering to make "all kinds of scrollwork for grates and staircases," which hints, at least, at the latter. In any event, all have been lost to fire or war (requisitions for military metals), and the earliest Charleston examples may date only from the 1760s. I say *only*, but by the standards of this continent that is

ancient enough. Wrought iron (iron that has been heated and worked by hand and hammer) became popular in Europe in the 1600s, and probably made its way to Charleston through French and English examples. Fashion aside (fire and war aside) Charleston's weather was tropical enough to rot away most wooden balconies, railings and fences, and the forged metal made a practical and graceful substitute. Indeed, for the best wrought iron, it's to the Southern coastal cities of Charleston, Savannah, New Orleans and Mobile that we should look. And to a degree, we will find similar motifs throughout the region for ironworkers made use of architectural pattern books and sometimes copied pieces that had been commissioned elsewhere. But only to a degree do we find this similarity.

"New Orleans has balconies, but Charleston has the gates." That's how master gardener Emily Whaley explained it to me years ago, and she's right—though our balconies are certainly *sufficient unto the day*. Charleston has its old-world neighborhoods, with houses and shops bordering close upon the sidewalks, but often as not, the single and double houses she's famed for are set back or at least have side yards that require the security of a substantial fence and gate. And as we are to brag upon our own, Charleston has far more wrought iron than her sister cities to the south. Cast iron (melted iron that has been poured into molds) was a popular Victorian substitute for the more traditional hammered metals. It's been called the plastic of the time. Any shape could be obtained and the theatrical whimsy of the age was often manifested: *Gothic* is the descriptive word most often applied.

And from the 1840s on, the balconies of houses, the columns of storefronts, yard jockeys, lampposts, gates, gateposts and all the rest were cast in this modern method. But by then Charleston had many of her impressive wrought-iron gates in place and a tradition and preference for that earlier process was well established. Today most ironwork is painted black, which is convenient for the reproduction of black-and-white photographs, but in times past, tan, violet, white and more were all in use. Times change and these earlier colors are coming back in favor.

Look to the shadows. I've seen the appreciation of decorative iron compared to Japanese haiku. The large church gates are objects of obvious beauty, but look to the smaller details, the craftsmanship of a simple handrail and the play of light upon a tapering spiral's tip.

As to who these craftsmen were we are often in the dark. In the 1800s three German blacksmiths, J.A.W. Iusti, Frederic Ortmann and Christopher Werner, were the best known. Jacob Roh was sometimes mentioned as well. Ortmann's sons continued to work into the twentieth century. No doubt African American men had been working on these shops from the beginning, and in our time, one of these, Philip Simmons, emerged as Charleston's foremost ironworker. You'll see several examples of his work in these pages and even have a glimpse of the park dedicated to his life and work.

Enjoy.

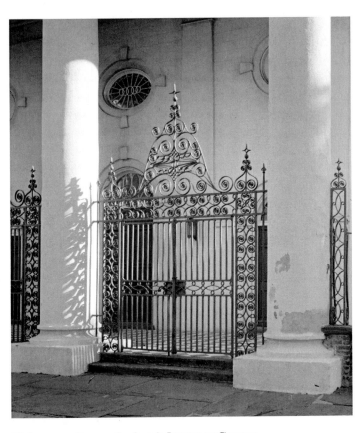

10 ARCHDALE STREET, ST. JOHN'S LUTHERAN CHURCH
One of three front gates, this 1815 ironwork is praised for its
craftsmanship but some find fault in the massive overthrow. Colonel Deas
considered the gates the beginning of the "new" undisciplined age and
ended his book *The Early Ironwork of Charleston* at this site.

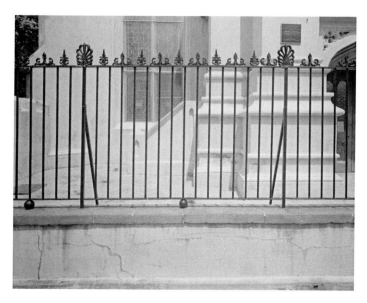

6 ARCHDALE STREET, UNITARIAN CHURCH
A simple fence and gate designed by architect Francis D. Lee in 1852.
The elaborate ironwork was saved for the interior remodeling of this
1787 church.

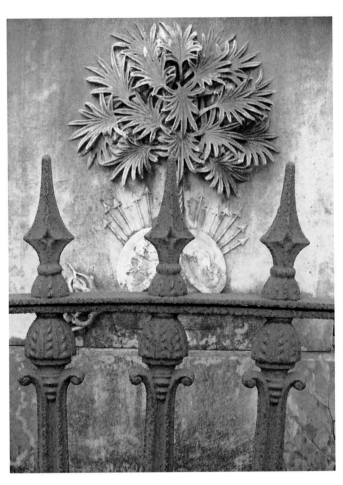

10 ARCHDALE STREET, LUTHERAN CHURCH CEMETERY
Spears in wrought iron and stone.

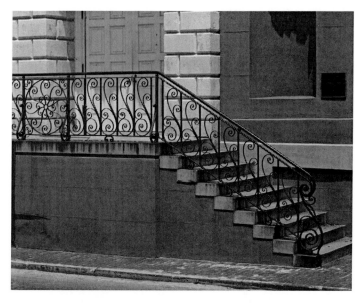

BROAD STREET
Technically the Exchange Building is on East Bay, but it belongs to
Broad. The original balustrade of the 1760s building was of stone. The
ironwork was added around 1800 and has been repaired or replaced at
least twice. The dome and attending hardware have been replaced as
well.

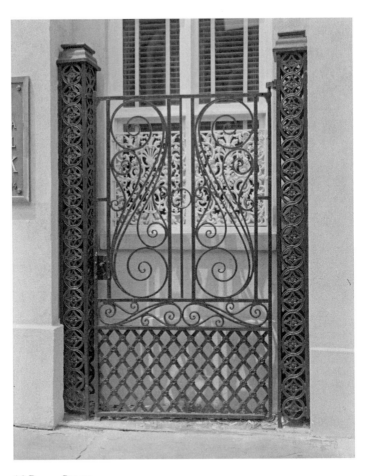

16 BROAD STREET
An 1817 bank building with false wrought-iron gate overlaying a cast-iron grille. The ironwork dates from an 1850s remodeling.

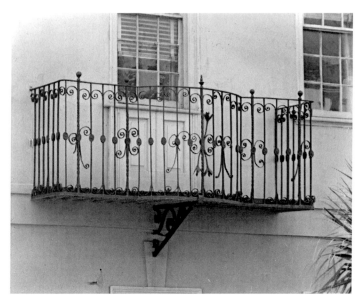

49 BROAD STREET

A lotus-flower design with accompanying scrolls and twisted intermediaries. This handsome little balcony with the single support is among Charleston's oldest—built before 1770. Colonel Deas considered it one of the finest in the city.

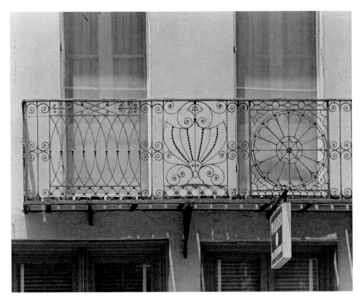

This page and opposite:
60–64 BROAD STREET

Following the Great Earthquake of 1886, this Home for Confederate Widows and Orphans was given a Victorian face-lift. "Delicacy of feeling, nimbleness of design, harmonious variety and suitable lightness of members," wrote Gerald Geerlings. "The average modern 'Colonial' railing is put to eternal shame by these."

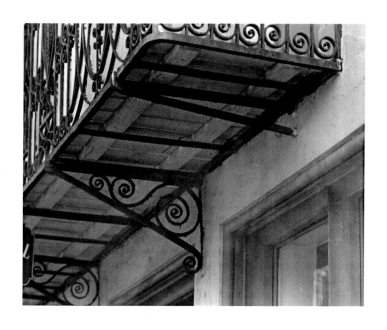

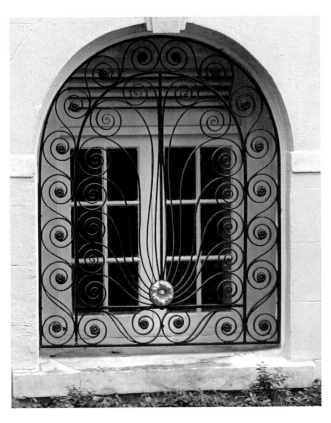

80 BROAD STREET, CITY HALL
Charleston premiere amateur architect Gabriel Manigault
designed this former bank building and its ironwork. Though
popular in England long before, this rear-facing window guard is
the first Charleston use of the Greek honeysuckle or anthemion
(sometimes called the peacock scroll). Soon they'd become
popular—but usually in a cast-iron version.

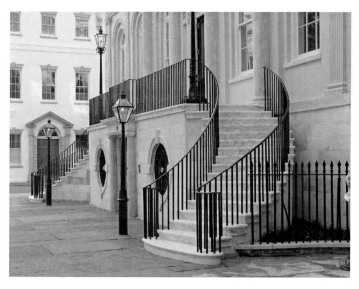

BROAD STREET, CITY HALL
Seen from the front, the simple but strong lines of newels and railings are a fine compliment to this Federalist hall.

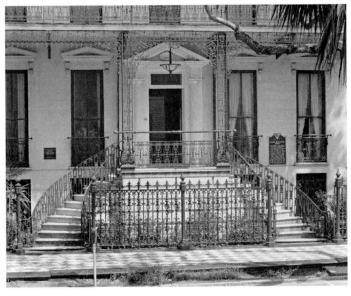

116 BROAD STREET, THE RUTLEDGE HOUSE
One of the best known and most profusely decorated of Charleston's
buildings, this home of "Dictator" Rutledge dates from before the
Revolution. The modernized railings and lampposts were added in 1853
by master ironworker Christopher Werner while the home was owned by
Thomas Gadsen.

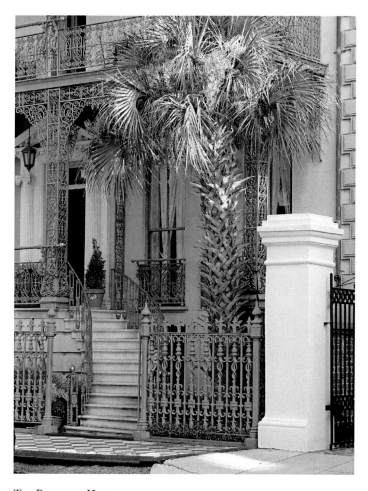

THE RUTLEDGE HOUSE
The living palmetto is appropriate to the spot for at its base are…

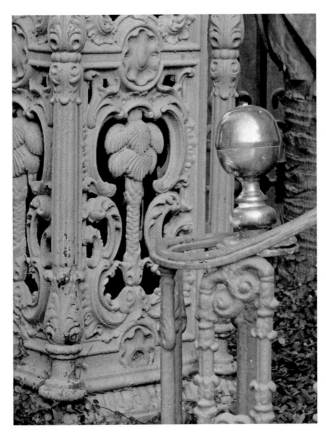

THE RUTLEDGE HOUSE

…cast-iron palmettos. They honor the state's Palmetto Regiment for its service in the Mexican War. American eagles are cast above them—perhaps a political comment.

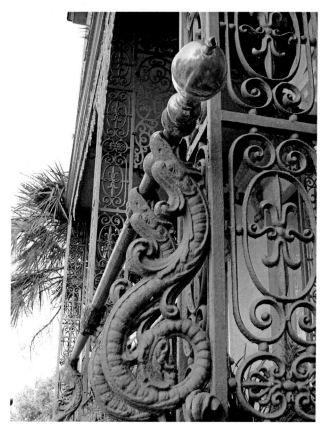

THE RUTLEDGE HOUSE
Though usually placed high and hard to recognize, these cast-iron dragons are more common than you think. With beaks fastened to this low railing, they're easy to spot.

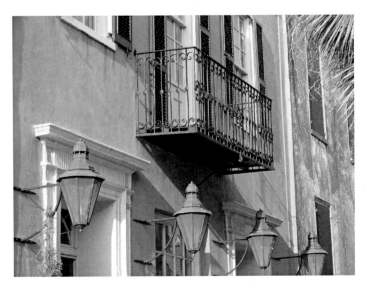

This page and opposite:
UPPER BROAD STREET
New lanterns but an ancient gaslight shape—a fine complement to the iron above. These newly minted scales are borrowed from a blind justice. Broad Street is famed for its lawyers and gifted legal secretaries.

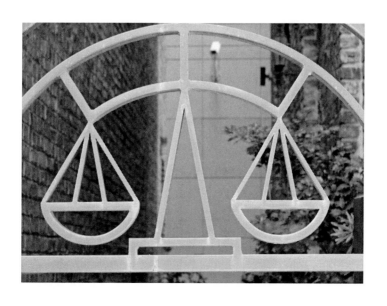

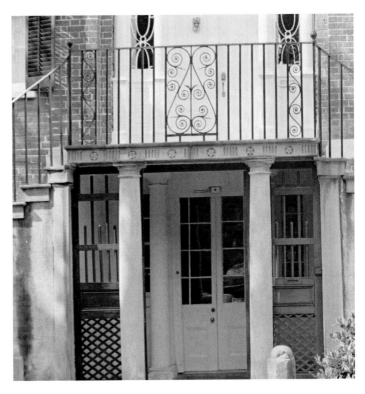

18 Bull Street, the Blacklock House

The lyre could take many shapes and was a very popular design element. Here is a highly stylized, single-string one. The rail and iron terminal balls are from an earlier tradition, but both are probably original to the 1800 house. Again Colonel Deas sees a sign of coarsening and regularity. Lyres would become a frequent motif and the workmanship hastier. "These modern times" was his 1941 complaint. What would he make of this present moment?

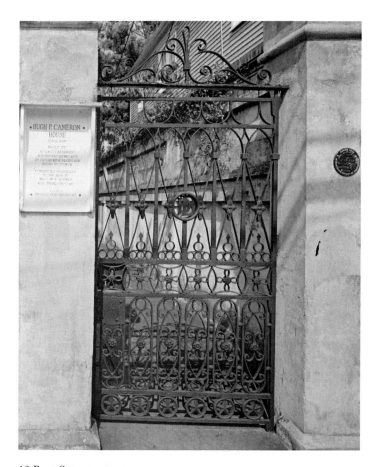

12 Bull Street

As with the gate that follows, both wrought iron and cast iron are combined. Scrolls and circle motifs and (at the center) the cipher of owner D. Bentschner appear in this 1880s gate.

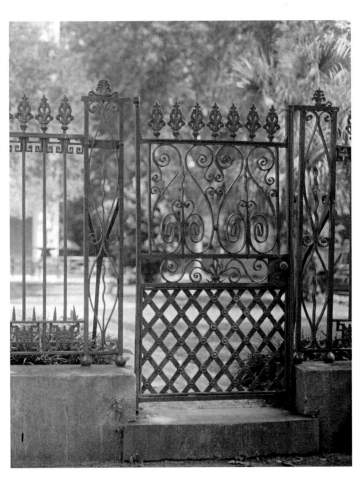

43 BULL STREET
Here cast iron predominates.

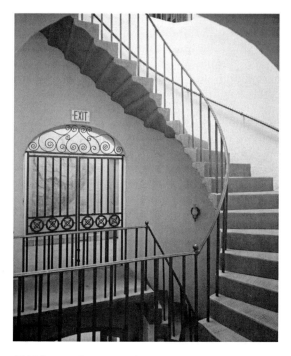

100 MEETING STREET (AT CHALMERS), THE FIREPROOF
BUILDING
America's first native-born architect, Robert Mills,
designed this fire resistant building to house the state's
public records. Simple and graceful, the iron rails run
three stories—top to bottom. And the window motifs
are repeated throughout the building. The architect's
Classical Revival designs called for massive columns and
accompanying detail, but the ironwork he suggested was
of a different nature.

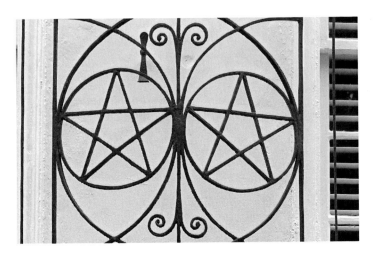

This page and opposite:
36 CHALMERS STREET
Twentieth-century architect Albert Simons designed this gate and balcony for novelist Josephine Pinckney. Those are her slightly disguised initials in the gate. Occasionally, he'd slip in the initials of his architectural firm, as well, but here we just have stars for the balcony.

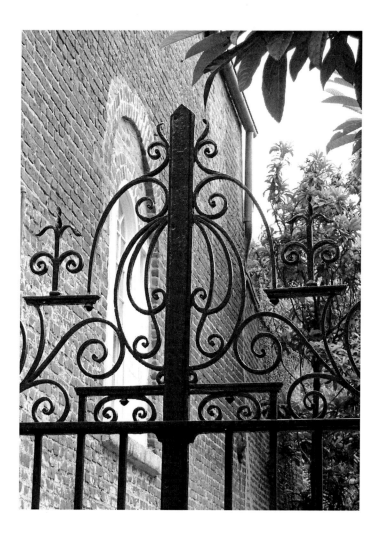

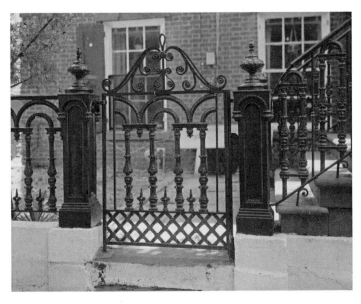

33 CHARLOTTE STREET
Spooled legs arched over and crowned with *C* curves.

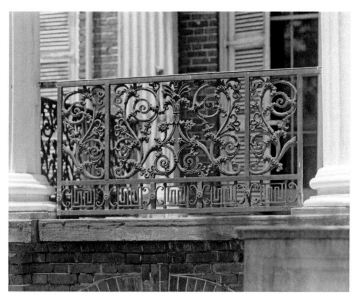

20 CHARLOTTE STREET

Cast-iron railing for this 1848 house. A row of Greek keys gives base to two wildly blooming lyres. Similar to the balcony of Petigru's law office.

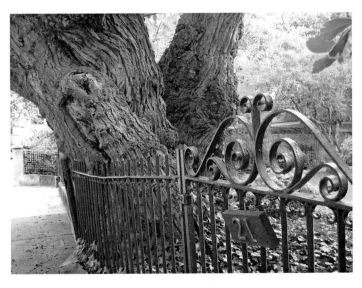

This page and opposite:
LOWER CHURCH STREET
The iron curves of nature are here faced with the real thing. A tree
encroaches on this long-standing fence. The rose bush is more forgiving.

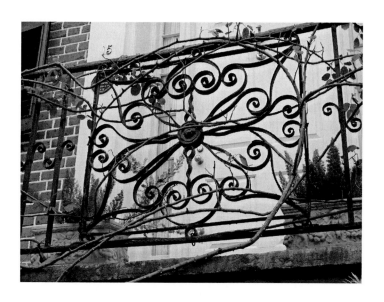

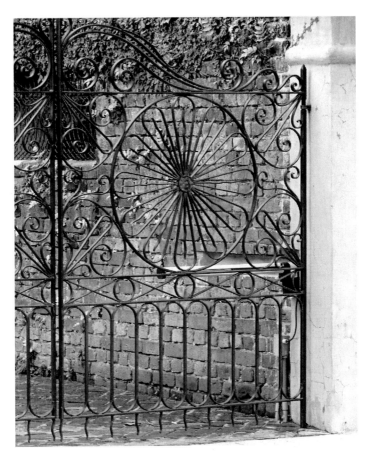

LOWER CHURCH STREET
A carriage gate composed of a central blossom encircled by circles and
Cs. Note the spike trim across the bottom. That's to keep the dogs from
digging under.

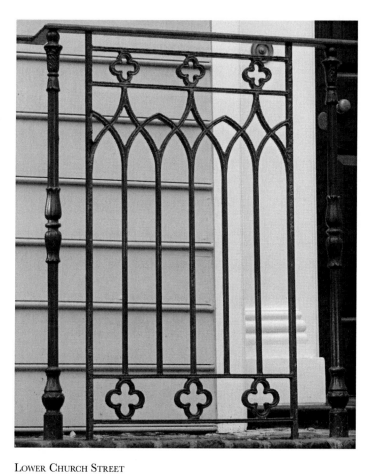

LOWER CHURCH STREET
The spooled uprights and Gothic grille wouldn't look out of place inside
a church—but then, this is Church Street. Suits the stoop.

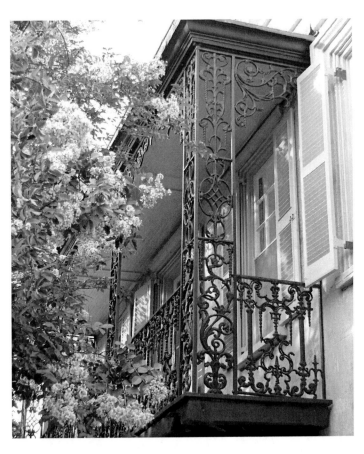

78 CHURCH STREET

This cast iron literally drips from the top rail. A popular design when the Gothic Revival style began to exercise its ornamental might. The large, roofed balconies are common to Mobile and New Orleans, but comparatively rare in Charleston.

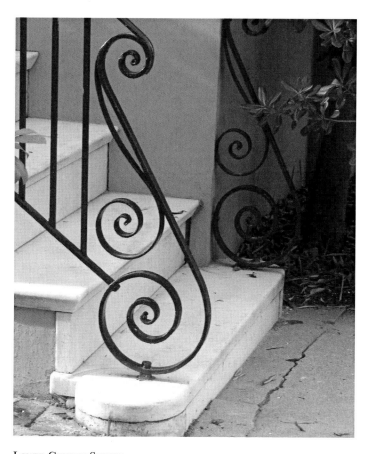

LOWER CHURCH STREET

Less is more. Certainly that's the case for this house built on a bet. Could the owner build on the narrow lot and still have every room fitted with a porch? He could. The carriage port was placed beneath the chimney.

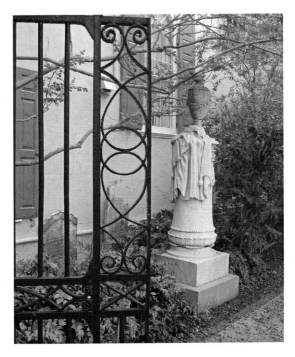

61 CHURCH STREET, FIRST BAPTIST CHURCH
This church is considered architect Mill's finest Charleston
accomplishment. (He also designed the Washington
Monument.) Massive classical lines for the church and
for the fence and gate are a fitting if simple working of
classical devices. "Simple and vigorous," says Colonel
Deas. Charleston's best-known blacksmith, Philip
Simmons, built a modern gate to match for the nearby
Sunday School Building.

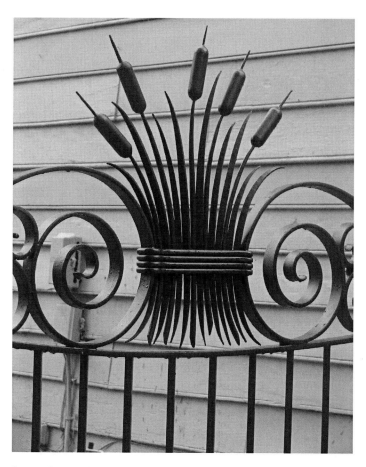

LOWER CHURCH STREET
Cattails. This modern and playful foliage tops the traditional carriage
gates. No Greek honeysuckle here.

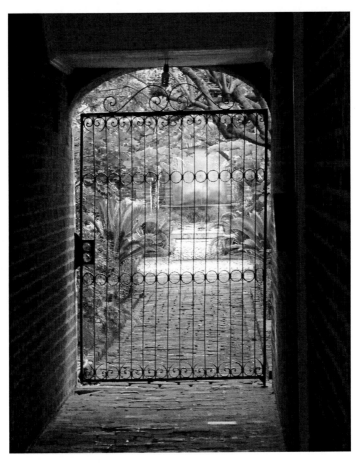

LOWER CHURCH STREET
This simple combination of circles and curls offers a teasing glimpse of Porgy and Bess's domain.

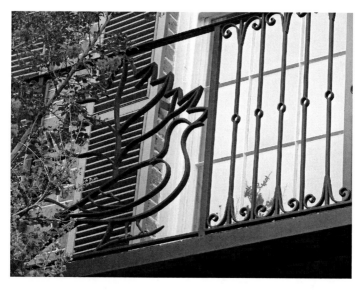

LOWER CHURCH STREET
We're almost up to Broad Street. This dove of peace is by another
modern blacksmith. Rich Averett of Old Charleston Forge did the work.

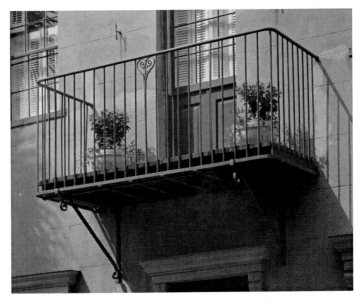

44 Queen Street

Colonel Deas identifies this as an early balcony and points out that the balusters are square in cross section but set edgewise to the rail, which along with the center baluster is round. That's a cipher for the original owner in the small centerpiece.

100 Block of Church Street
One of the earliest examples of ironwork in the city. Colonel Deas points
out that it is riveted and rather crudely done.

100 BLOCK OF CHURCH STREET
There are six interesting balconies on this block.

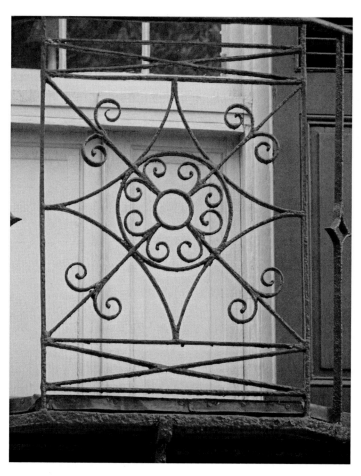

100 BLOCK OF CHURCH STREET
Detail of balcony.

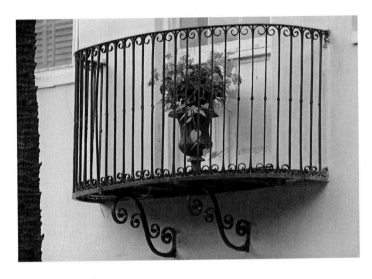

124 Church Street
These little pulpit balconies are surprisingly rare.

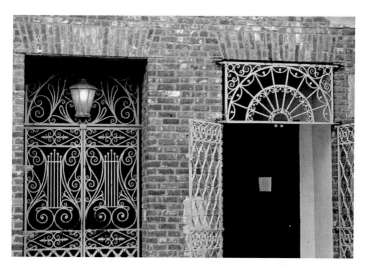

135 CHURCH STREET, DOCK STREET THEATRE
The two ironwork gates were designed by Albert Simons in 1935 and
appear to be a sophisticatedly playful amalgamation of every nineteenth-
century gate in the city.

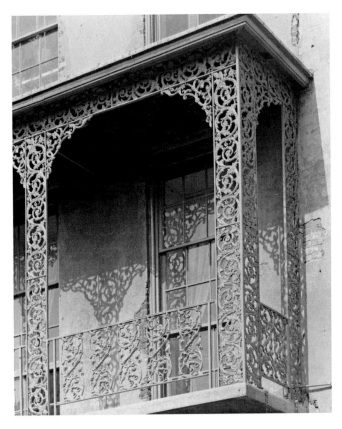

This page and opposite:
Dock Street Theatre
Cast iron in stock patterns. This morning glory pattern was popular all the way down to New Orleans and probably came from a Philadelphia manufacturer around 1835. Those on the Mills House (reproduced for the new Mills-Hyatt) dated from the same period and came from the same source.

48

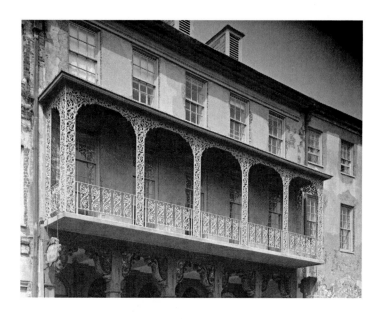

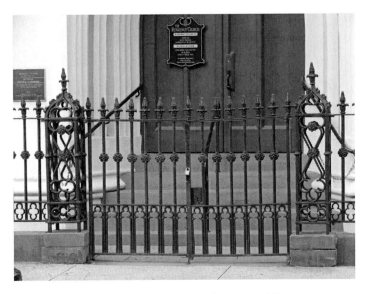

136 Church Street, French Huguenot (Protestant) Church
Cast iron formed in a fittingly Gothic Revival style. The finials and
pinnacles of the church also are made of iron. E.B. White designed the
1845 church and probably did the gate and fence design as well.

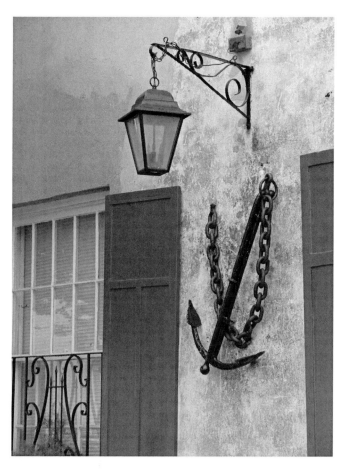

Upper Church Street, "The Pirate House"
Lamp, anchor, chain and a harp for window guard. The wall behind
is Bermuda coral with a coat of mottling stucco.

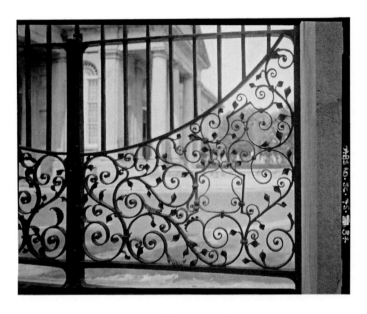

146 CHURCH STREET, ST. PHILIP'S EPISCOPAL CHURCH
Western cemetery gate. A delicate floral design for a surprisingly early
gate. These date from before 1776. An even earlier overthrow was taken
down from the eastern gate entry for it contained an unfashionable skull
and crossbones and dire warnings of inevitable death. The gate was
removed when the YMCA was built.

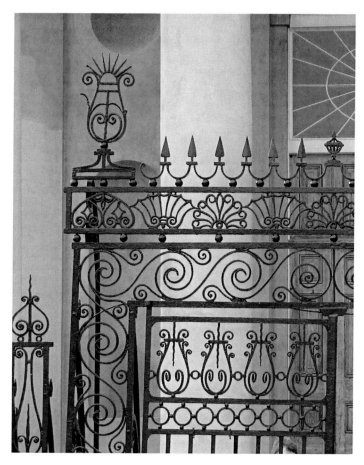

St. Philip's Episcopal Church
A crest of spears with urn motifs crowns the overthrow, and beneath are
a row of palmettoes, seashells and then scrolls.

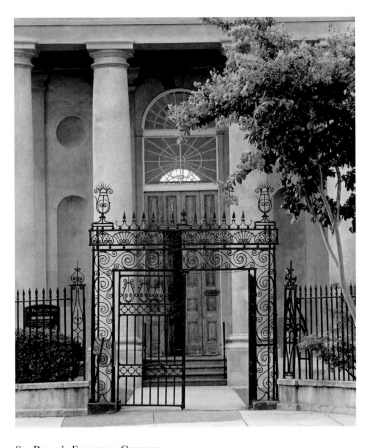

St. Philip's Episcopal Church

These landmark wrought-iron gates probably date to around 1838. Joseph Hyde was the church architect, but the maker of the gates isn't known.

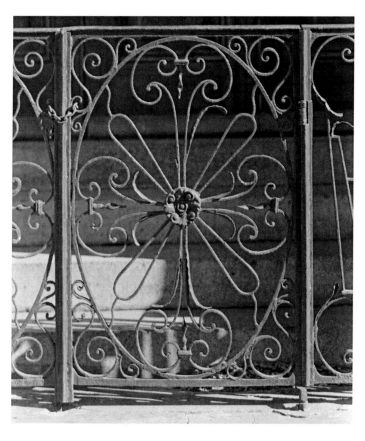

ST. PHILIP'S EPISCOPAL CHURCH
Found now at the center portico, this may be a portion of an earlier
church's communion rail. The similarity to the St. Michael's rail is
obvious, and Colonel Deas suggests this elongated version of that rail is
Colonial made.

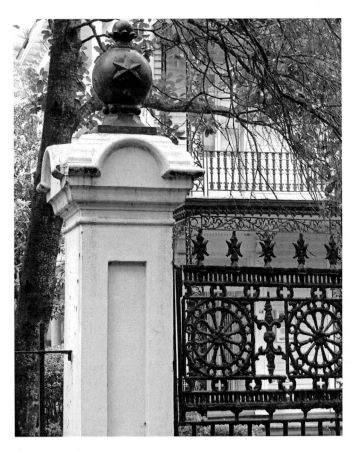

COLLEGE OF CHARLESTON
Iron ball with star for gatepost finials and the accompanying gates
were brought from another site. In the background is the cast-iron
railing of a house-fronting balcony.

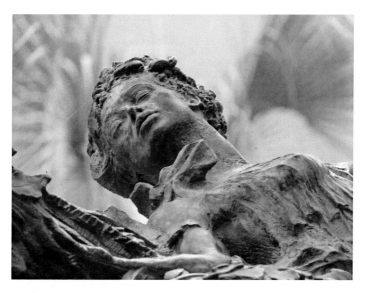

COLLEGE OF CHARLESTON
A sleeping bronze. Spider webs on her right ear.

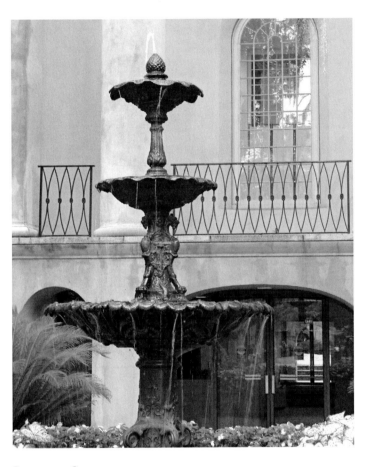

College of Charleston
A cast-iron fountain in three layers is complemented by the lace of bent-rod rail beyond.

COLLEGE OF CHARLESTON
April azaleas.

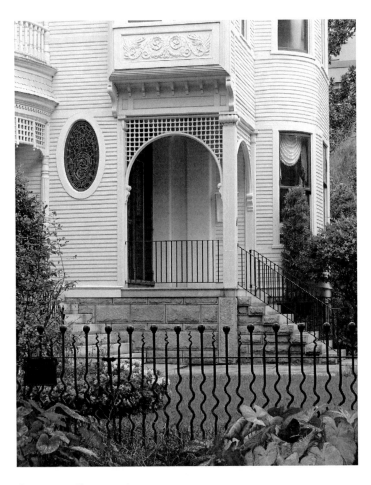

COLLEGE OF CHARLESTON
The Sottile House bordered by a fence of alternating rods. Champagne corks and accompanying corkscrews.

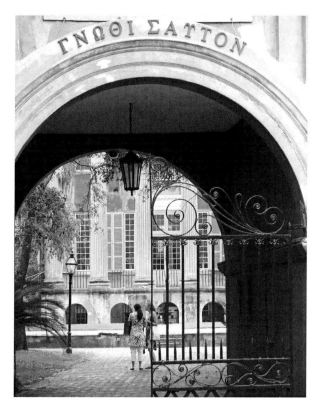

COLLEGE OF CHARLESTON

This Greek invitation is from Plato's *Dialogues*. "Come to know thyself." Twentieth-century architect Albert Simons placed a Latin inscription from Virgil on the Calhoun Street entry. Aeneas was being threatened by a whirlpool and lured onto the rocks by the sirens at the same time. It reads: "Some day it will be pleasant to remember even this." School days.

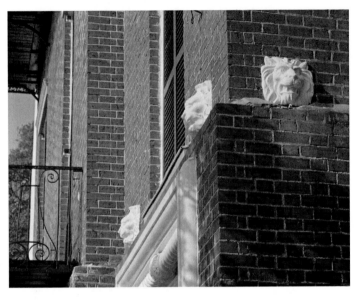

This page and opposite:
9 EAST BATTERY, WILLIAM ROPER HOUSE
Following the Great Earthquake of 1886, reinforcing earthquake rods
were run through most of the masonry houses and bolted from the
outside. Here the nuts are disguised as iron lions. The balcony probably
owes the circular motifs to the St. Michael's communion rail. The lyres
are more conventional.

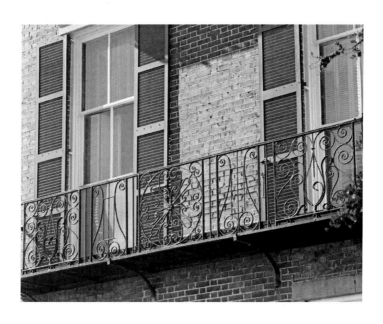

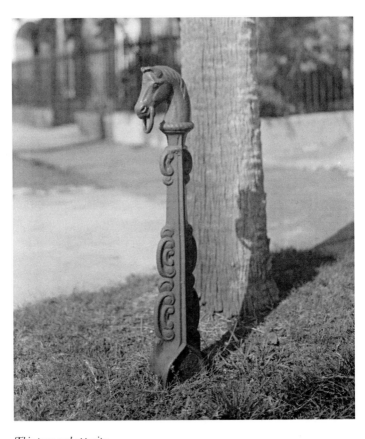

This page and opposite:
13 EAST BATTERY, WILLIAM RAVENEL HOUSE
The hitching post horse was once both adornment and necessity.
The house's tremendous classical portico was destroyed by the 1886
earthquake and this balcony took its place. An odd substitute, but now
Charleston's familiar Battery would look strange without it.

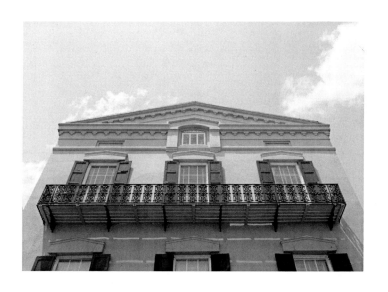

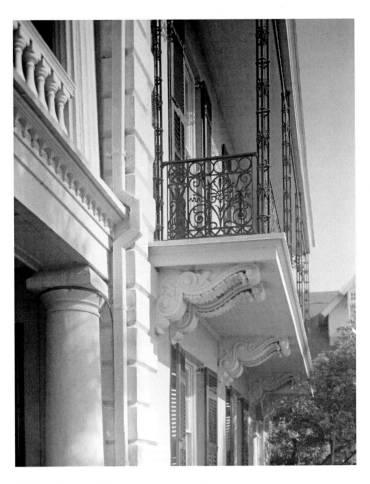

21 EAST BATTERY, EDMONSTON ALSTON HOUSE
Cast-iron balcony with cast-iron supports. This house is open to the public.

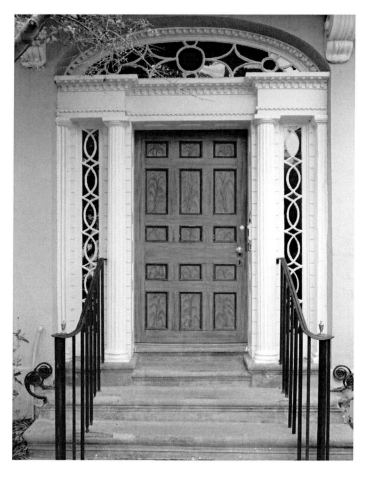

EDMONSTON-ALSTON HOUSE

Modest newels and rails for such a grand house. Note the boot scrapers to each side.

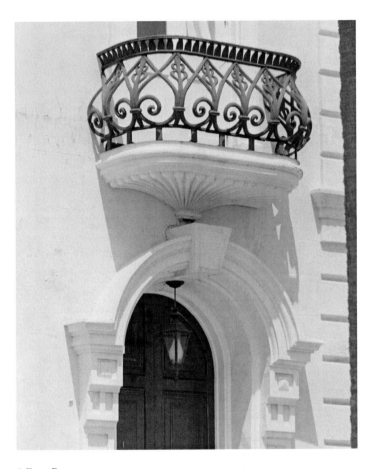

1 EAST BATTERY
One of three matching cast-iron, curved balconies added in 1888 to a house built between 1858 and 1861.

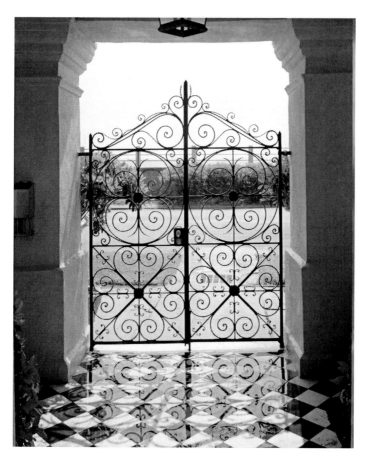

29 EAST BATTERY STREET, PORCHER-SIMONDS HOUSE
A favorite of mine. Four quadrants with floral arrangements of wrought iron in each. *J*s, *C*s and *S*s. This interior view isn't accessible to the general public.

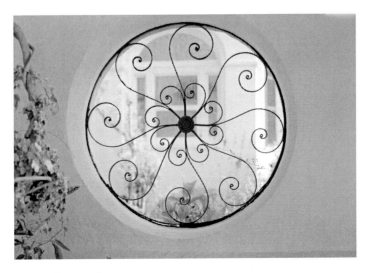

29 EAST BATTERY STREET
Clairvoyee near ground level.

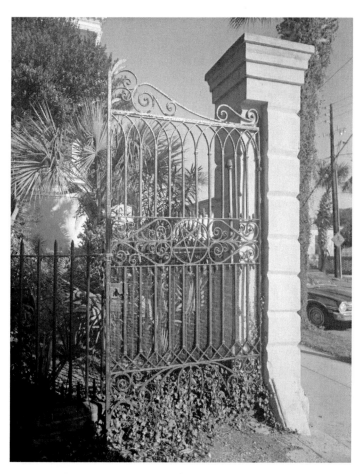

51 EAST BAY STREET
Wrought-iron gate. Note the recessed masonry for the hinges.

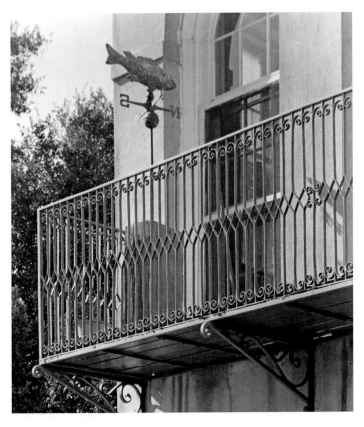

71 EAST BAY STREET

The weather vane draws our attention, but for ironwork aficionados the center of interest is the small bit of scrollwork to the far right. It breaks the monotony of this long balcony. The weather: southeast winds—what's called "a sea breeze."

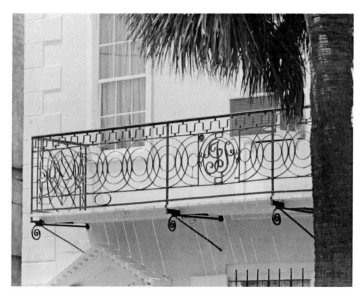

57 EAST BAY STREET

Gerald Geerlings chose a version of this balcony as an American
illustration for his wide-reaching study *Wrought Iron in Architecture*. The
owner's initials at the center, J.T., are for James Tate, who built at 2
Queen Street. The balcony was moved to East Bay.

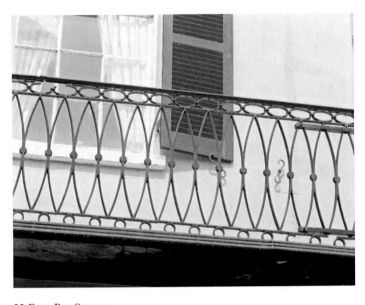

55 EAST BAY STREET
Bent rods played upon by circles and ovals.

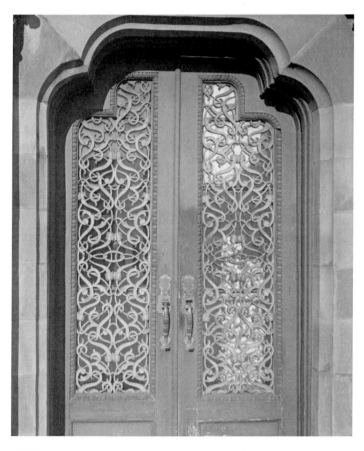

141 EAST BAY
Cast-iron door grilles of "The Moorish Bank." The 1853 building was
perhaps architect Francis D. Lee's most extravagant expression. The
vaulted interior made use of iron as well.

EAST BAY STREET, COMMERCIAL DISTRICT
Several blocks of cast-iron storefronts, but only this one boasts faces.
By 1850 there were nine foundries in Charleston, and East Bay, Broad,
Meeting and King Streets stand testament to their skillful output.

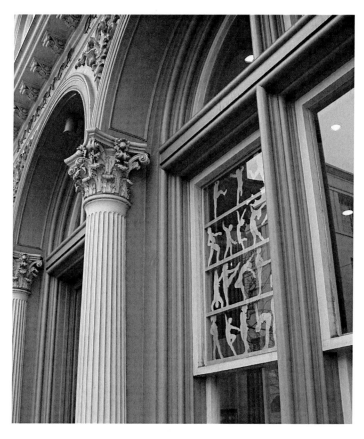

EAST BAY STREET, COMMERCIAL DISTRICT
Corinthian columns, arch and cornice are all of iron. This Victorian-
era invention allowed for quick, strong and handsome storefronts
without the expense or weight of stone and gave the added benefit of
more window space.

This page and opposite:
EAST BAY STREET, COMMERCIAL DISTRICT
Modern signs.

301 East Bay Street

A lethal porch guard. Gates, fences and window guards all serve to secure a building. Here the intention is made obvious.

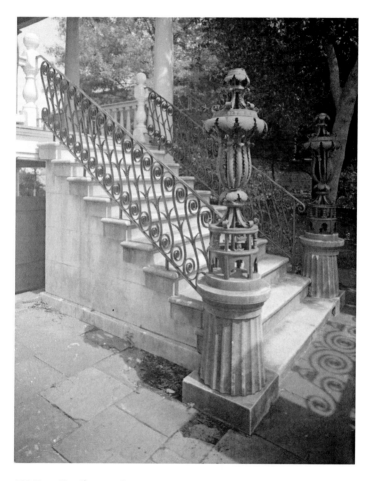

332 EAST BAY STREET, PRIMROSE HOUSE
An entry of both wrought- and cast-iron. Both the rail and stairs are a later
addition to the house.

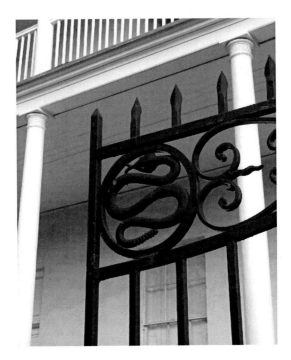

329 EAST BAY STREET

The "rattlesnake gates" were built in 1960 by Philip Simmons from a design by architectural historian Samuel Stoney. The coiled snake is a reference to the Revolutionary War flag designed by Christopher Gadsen—the "Don't Tread on Me" flag. Simmons took pains to make this a lifelike snake. Venomous. Forked tongue. Sinister eyes. Seven rattles. You can count them. The house was once owned by Gadsen's daughter and her husband.

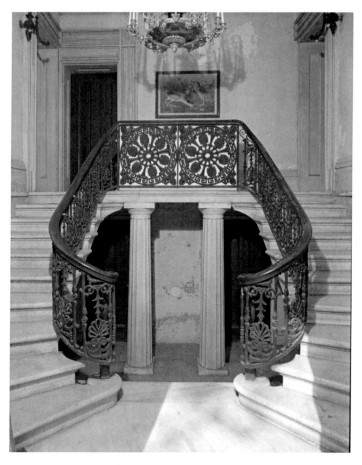

48 ELIZABETH STREET, AIKEN-RHETT HOUSE
An interior use of cast iron instigated by a Victorian remodeling. Open
to the public and a must-see.

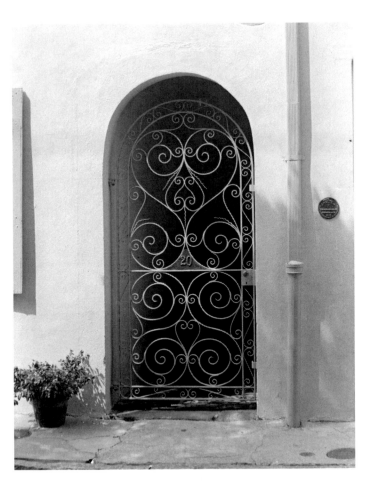

ELLIOTT STREET
A dizzying collection of *S*s.

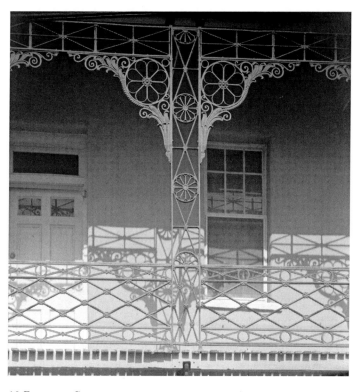

10 EXCHANGE STREET
With its cantering wheels, this cast-iron balcony is a cut above most.
Great shadows—even those cast by the balcony deck.

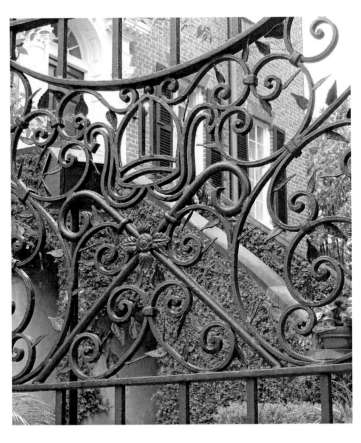

GLEBE STREET, THE EPISCOPAL BISHOP'S HOME
Architectural historian Sam Stoney designed this gate with references to the bishop's miter and crook and used the Western Cemetery gates of St. Philip's as his basic pattern.

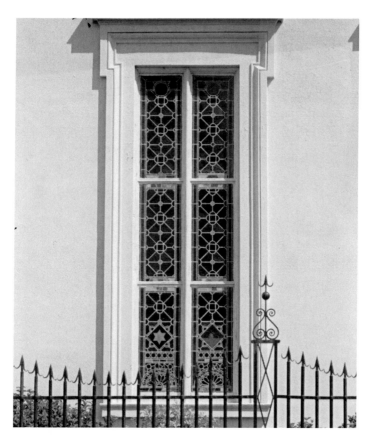

90 HASELL STREET, BETH ELOHIM SYNAGOGUE
In 1838 a fire swept through the neighborhood. This fence probably
dates from the original 1794 synagogue. The accompanying gate is
massively beautiful, but this simple composition of Bayless's appeals to
me—less being more.

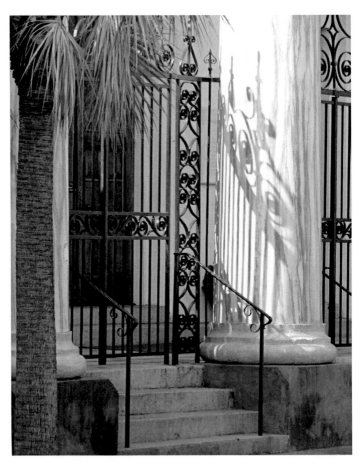

89 Hasell Street, St. Mary's Catholic Church
This church with its fronting gates dates to the same 1839 rebuilding effort. Shadows imposed upon a recent marbleizing.

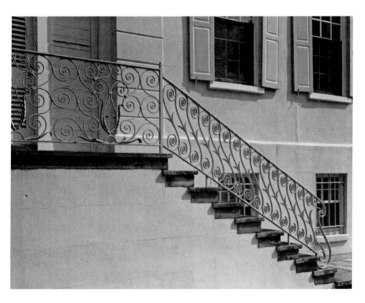

54 HASELL STREET, CAPTAIN WILLIAM RHETT HOUSE
The railing dates from a 1941 remodeling of this 1712 house. Pirate
fighter and much more, Rhett built his plantation house well beyond the
city's walls. Note the descent of the scrolls and how they play against the
landing rail. Harmony.

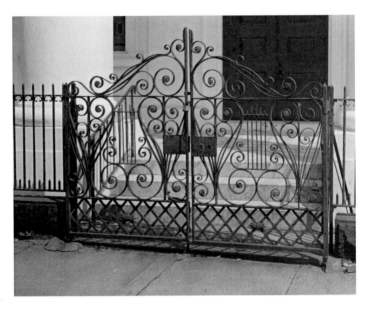

This page and opposite:
HASELL STREET
As with the King Street Lutheran Church, the gate and fence of St.
Johannes Lutheran Church are truly modest—by Charleston standards.
The carriage gates with burlap curtain have a familiar Greek key base.

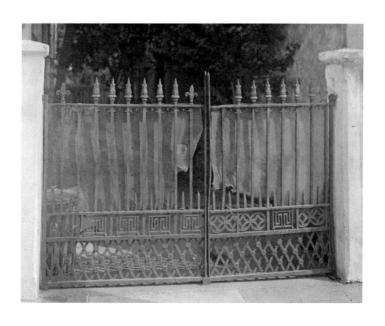

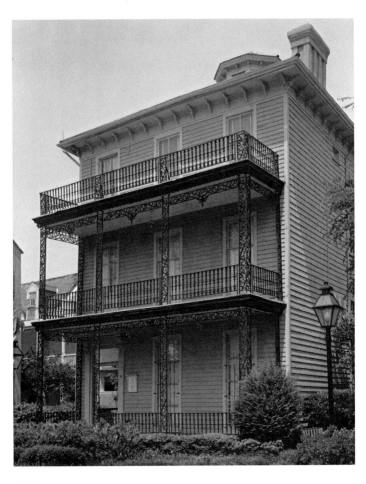

14 GREEN STREET

Green Street has wandered from its alphabetical order. Can't be helped.
Cast-iron balconies like these are rare to Charleston houses.

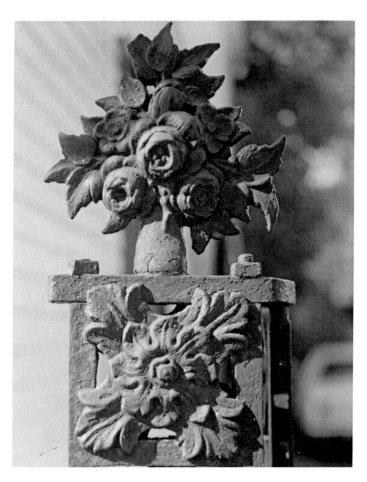

5 KING STREET
Iron roses crown the gateposts.

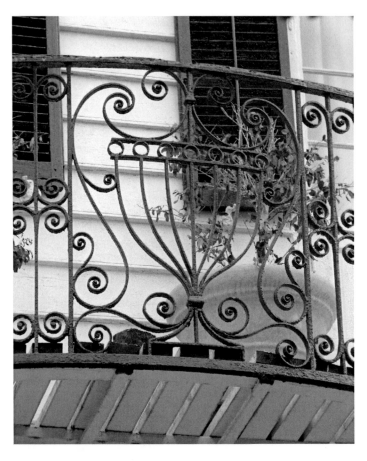

23 King Street

A simple urn—but Gerald Geerlings used it as an illustration in his *Wrought Iron in Architecture*. This balcony may have come from Broad Street.

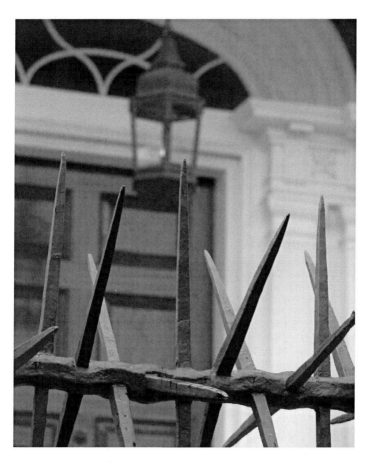

27 King Street, Miles Brewton House
These spikes (a cheval-de-frise) were added to the top of the fence shortly
after the failed Denmark Vesey uprising of 1822. The fear of slave
insurrection was an ever-mounting concern. The fence itself is simple pickets.

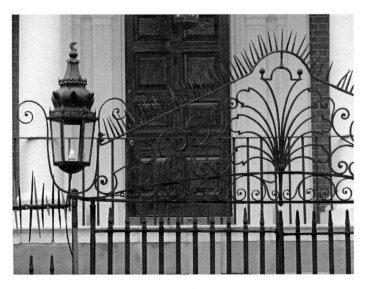

This page and opposite:
MILES BREWTON HOUSE
This is one of the two oldest examples of ironwork in Charleston and the only remaining early gate with an overthrow. Colonel Deas describes the center ornament as "a baroque shell" whose acanthus leaf underpinning has rusted away. The "tin" lanterns are replicas based on the originals that rusted away.

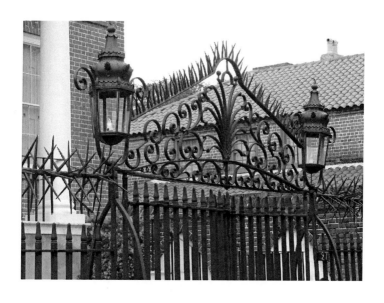

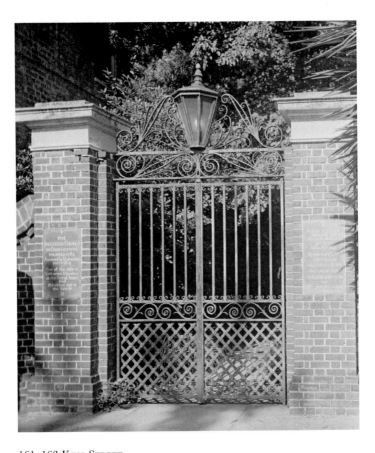

161–163 King Street

A part of landscape architect Loutrel Brigg's garden walk, this is the King Street entry into the rear of the Unitarian Cemetery. The gates were built by the Ortmann brothers in 1930 and were inspired by those at 32 Legare Street—sans swords.

460 KING STREET
A landmark.

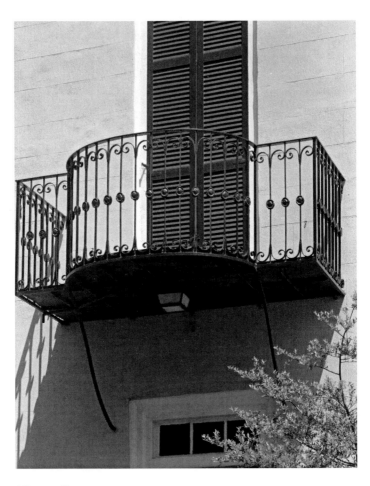

4 LEGARE STREET
A balcony by Philip Simmons, but one well in keeping with the
Charleston tradition.

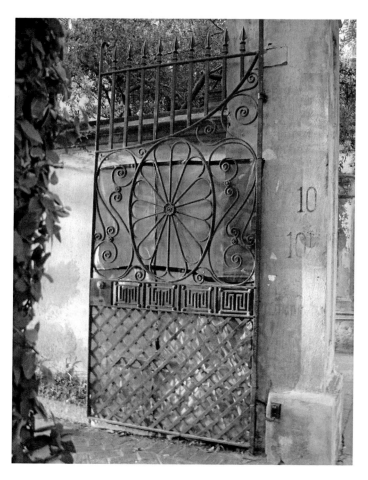

10 LEGARE STREET
Scrolls, blossom, spikes and Greek keys—warped by endless use.

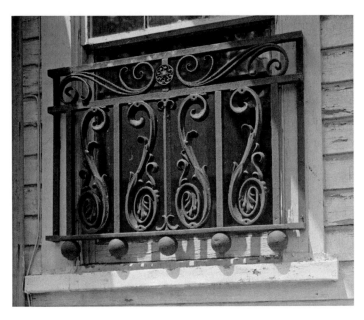

41 LEGARE STREET
Wrought iron above and cast iron below, all seated on five decorative balls.

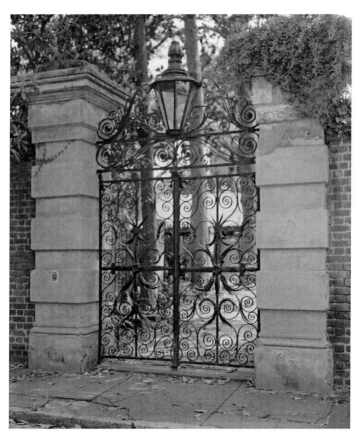

32 LEGARE STREET, SWORD GATES HOUSE
Working in both wrought and cast iron, craftsman Christopher Werner
first used this design for the city's Guard House gates. The Roman sword
and spear were to denote civil authority.

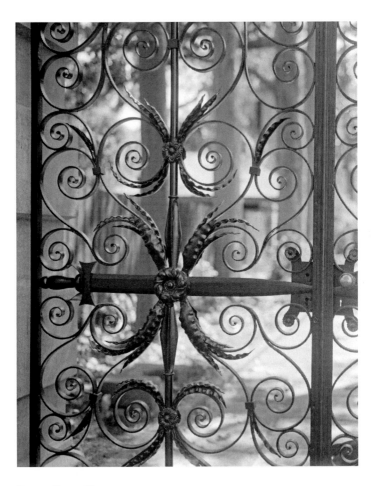

SWORD GATES HOUSE
Detail of sword gate.

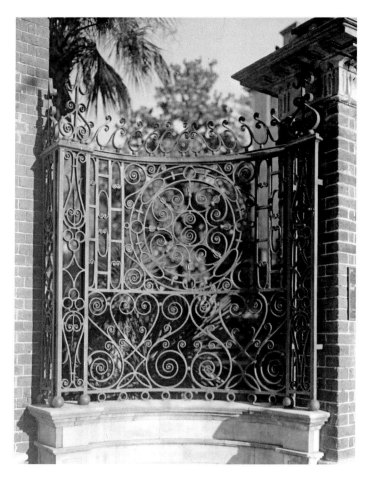

14 LEGARE STREET, "PINEAPPLE GATES" HOUSE
Actually these are Italian pinecones, but the message of welcome is the
same. The owner's initials are in the ironwork to each side of the entry.

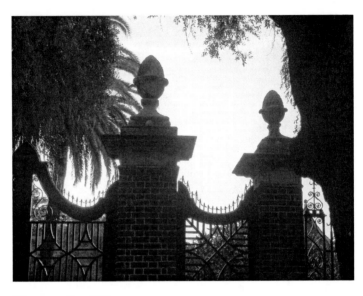

"PINEAPPLE GATE" HOUSE
First light. The iron portions of the wooden gates are seen in silhouette.

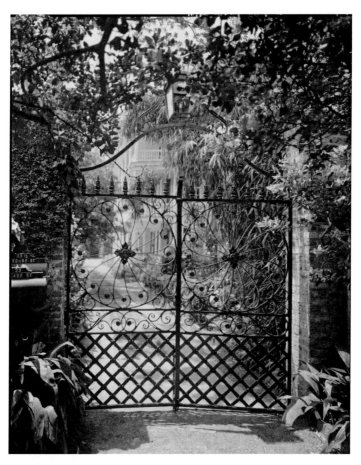

23 LEGARE STREET
Carriage gate with an overthrow and lamp of refined Adamesque proportions. These, Deas felt, were as they should be.

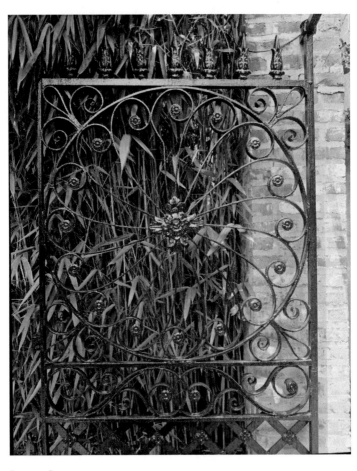

LEGARE STREET
Detail of gate. Cast-iron finials for a wrought-iron gate.

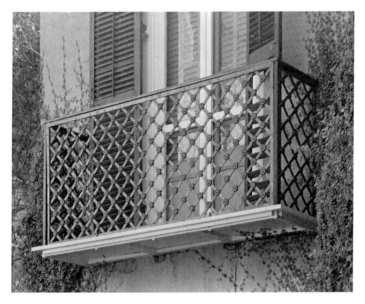

25 LEGARE STREET

Iron lattice trimmed in rosettes is more familiar to the lower portion of gates (dog guards they're sometimes called). Found on a balcony this pattern has a vaguely industrial look—for we've come to expect flowers, harps and what some might call material dishonesty. Some say iron should look like iron.

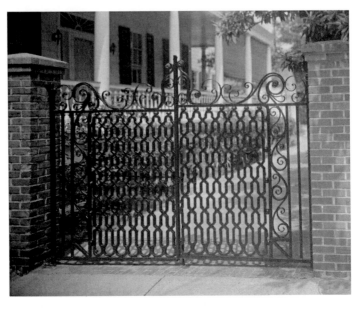

38 Legare Street

A pleasing variation on the last mentioned theme. A compromise.

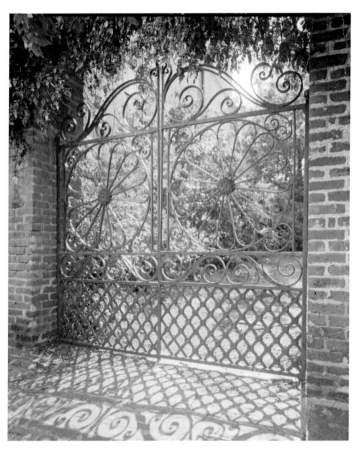

9 LIMEHOUSE STREET
Afternoon light. House and gates circa 1856.

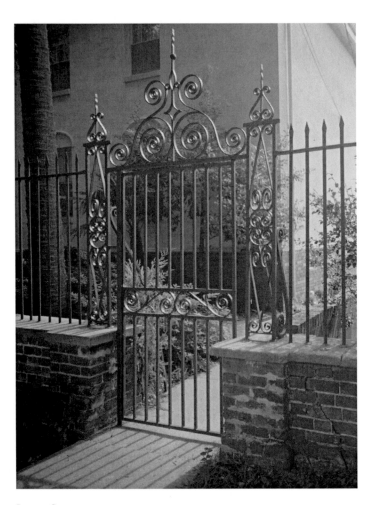

LOGAN STREET
And more light.

112

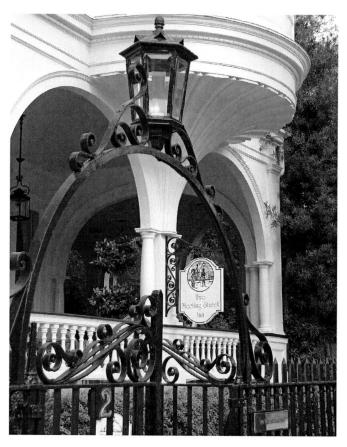

2 MEETING STREET

The bed-and-breakfast has incorporated the gate into their sign. By some standards the overthrow is too massive, but the Victorian arches are well complimented.

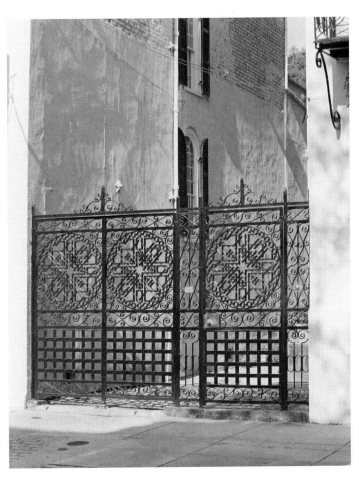

27 MEETING STREET
Cast iron.

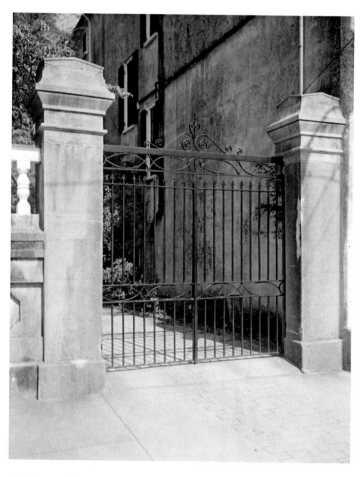

34 MEETING STREET
A Philip Simmons carriage gate in the old Charleston tradition.

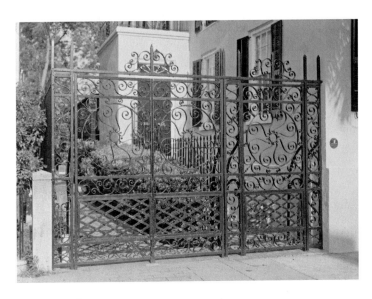

43 MEETING STREET
Carriage gates of circling scrollwork and lattice.

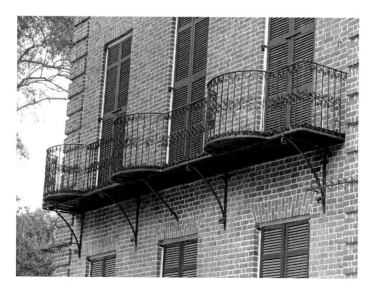

18 MEETING STREET

A large, brick, single house built in 1803 and once owned by Declaration of Independence signer Thomas Heyward. Look close. Beneath the balcony are the remnants of a cheval-de-frise—the preventative of that age.

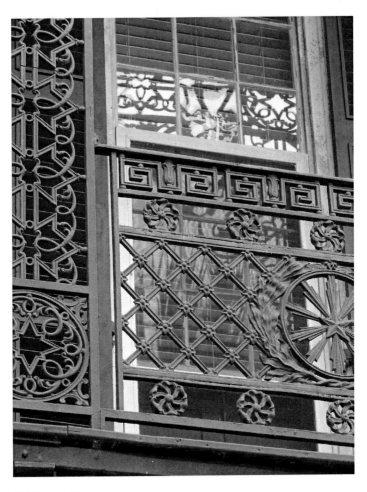

37 MEETING STREET
Stars and bars and Greek keys at the railing.

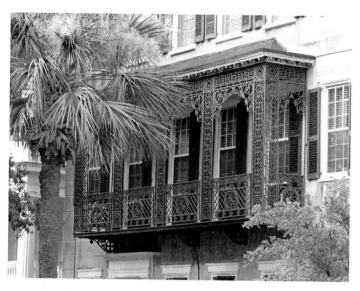

37 MEETING STREET
Relatively rare to Charleston and common to Mobile and New Orleans.

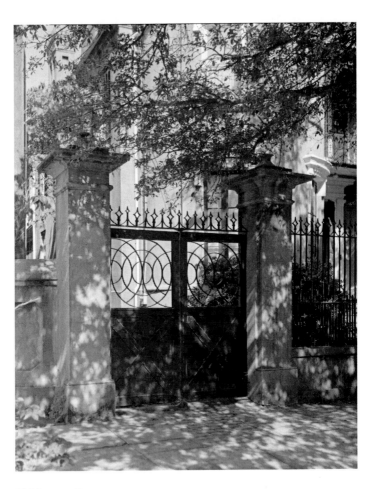

37 MEETING STREET
Wooden gates with iron "windows."

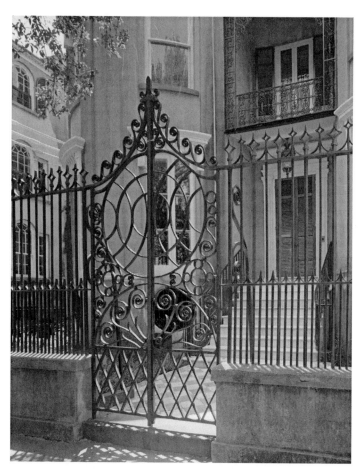

37 MEETING STREET
A source for the carriage gates. Note the half circle below the whole.

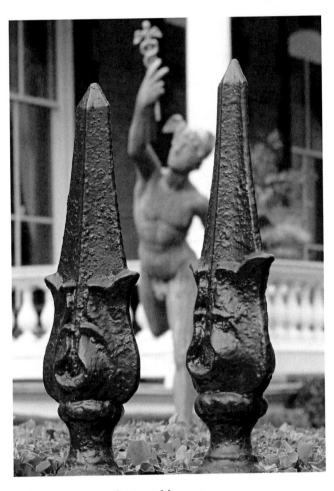

16 MEETING STREET, CALHOUN MANSION
Cast-iron spears—geometric points grow from an organic base.

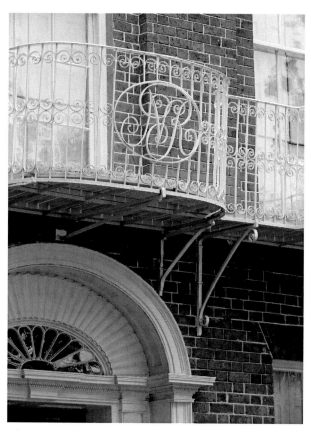

51 MEETING STREET, NATHANIEL RUSSELL HOUSE
Yankee businessman Nathaniel Russell left his mark (N.R.) on
the city. I assume that white is the original color and not the
black we've all grown used to.

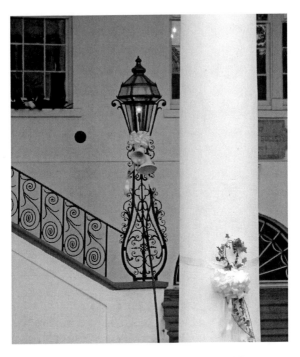

72 Meeting Street, South Carolina Society Hall
The stair rails (high-scrolled *S*s with husks) are in the
Adamesque style popular to Charleston in the beginning of
the nineteenth century. But, attached at a later date, these
"Georgian" lamp stands are some of the oldest ironwork
in the city and predate the building by half a century.
Glimpsed behind the column, the Adamesque fanlight is
praised by Colonel Deas for its "purity and simplicity." A
favorite site for wedding receptions and the like.

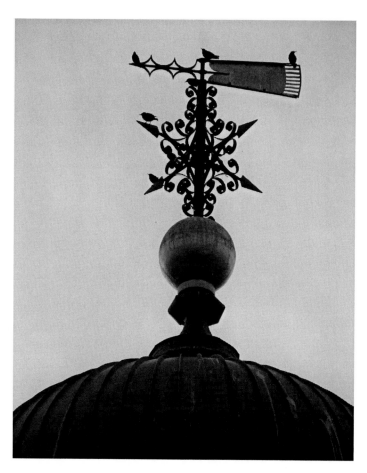

57 MEETING STREET, FIRST SCOTS PRESBYTERIAN
A brass globe topped by an iron wind vane. Sparrows cloaked in feathers.

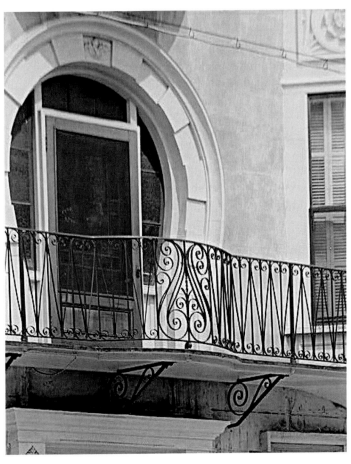

MEETING STREET
A balcony of the Victorian era.

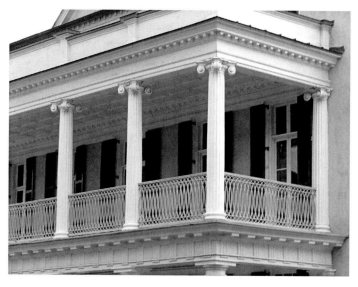

MEETING STREET
Balconies rarely extend over Charleston sidewalks, but when they
do, solid Classical Revival columns are involved. Not the spindly iron
supports of more tropical climes.

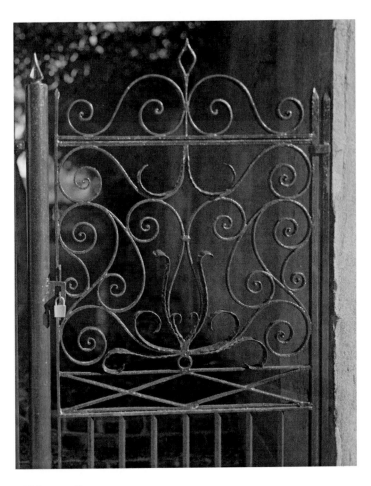

36 MEETING STREET
Another Philip Simmons gate. A favorite of mine.

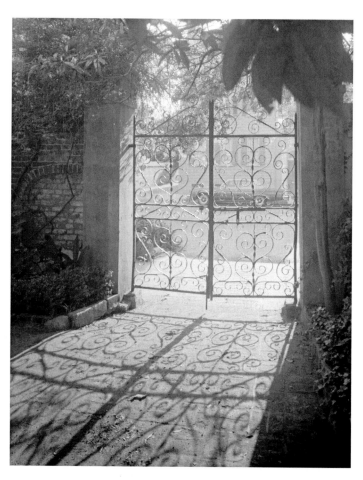

63 MEETING STREET
Dizzying scrollwork, especially when doubled.

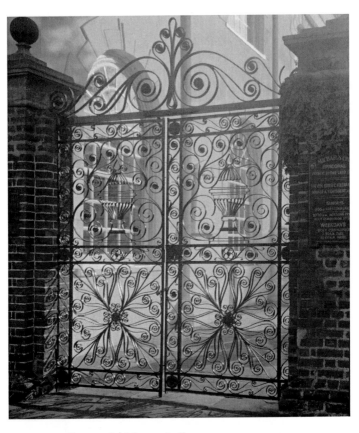

80 MEETING STREET, ST. MICHAEL'S CHURCH

I suspect this is one of the best-known church gates in the world. German ironworker J.A.W. Iusti signed the overthrow. Funeral urns are a fitting motif—and the gates are free from the more usual spikes and other devices of conflict.

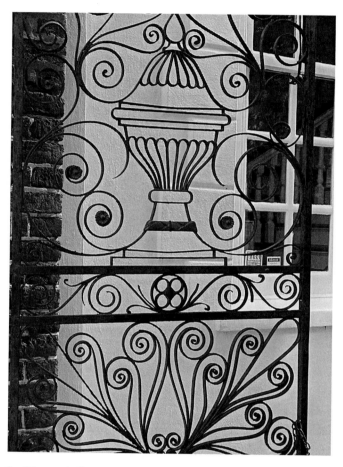

ST. MICHAEL'S CHURCH
In good wrought-iron work, the iron becomes thinner as the scroll
evolves. Like this.

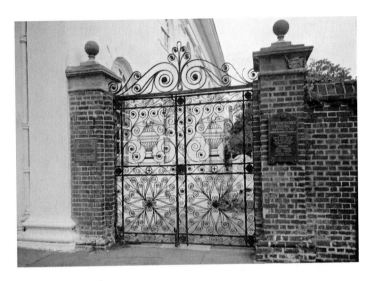

This page and opposite:
ST. MICHAEL'S CHURCH
The exterior gate is familiar, but the communion rail should be as
well. The vestry ordered this communion rail from England in 1772.
A circular design with fiddle- and lyre-shaped ironwork on either side,
the rail was often copied for other churches and for house gates and
balconies. The replaced panel of the William Gibbes House's rail and
the portal gates of St. Philip's are thought to be in its debt.

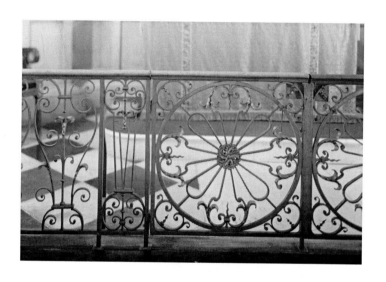

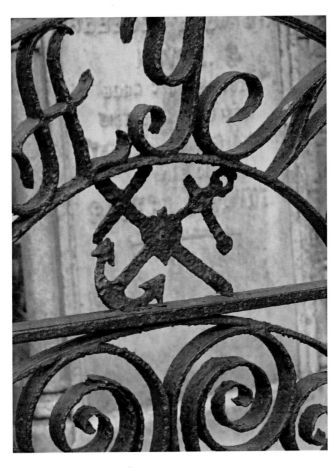

St. Michael's Church Cemetery
This little device would fit in the palm of your hand. Anchor and cross.

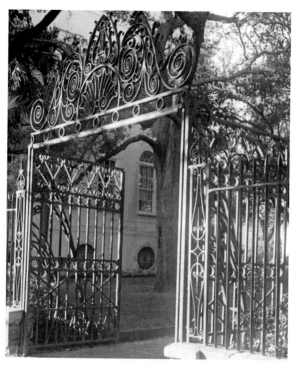

90 MEETING STREET, WASHINGTON SQUARE

At the time of the gate's construction, a letter to the local
paper suggested that the builder find another line of work.
But his complaint was apparently directed at where the
fence ran. Later critics pointed at the massive overthrow,
claiming it was out of proportion to both fence and
neighborhood. Robert Mills, who designed to the left, and
Gabriel Manigault, who designed to the right, would have
agreed.

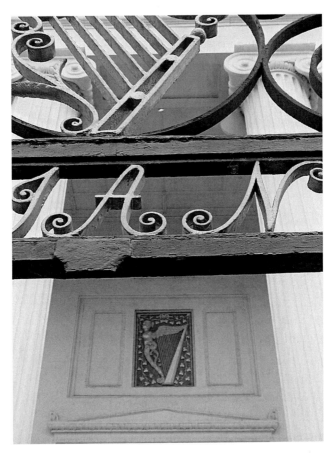

105 MEETING STREET, HIBERNIAN SOCIETY HALL
The gold enameling was common in England at the time, but
rarer here—and even our few examples are often painted over.

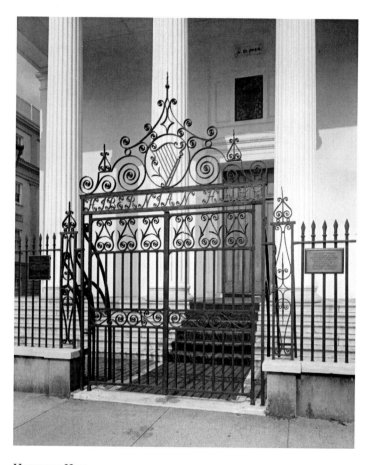

HIBERNIAN HALL
This gate was installed soon after the one found on Washington Square.
Christopher Werner was the maker.

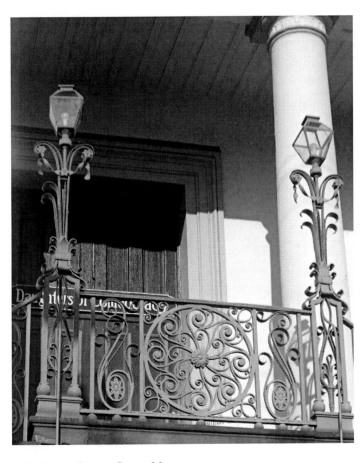

188 MEETING STREET, PUBLIC MARKET
Another well-known railing and light stand arrangement. E.B. White was the architect and the iron is original to the 1841 building.

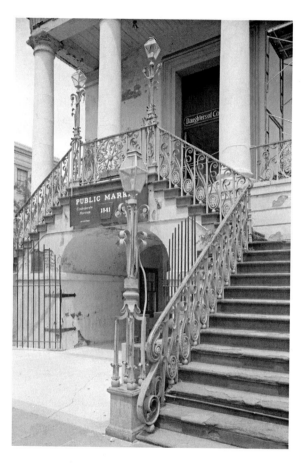

Public Market

Detail of landing. The sidewalk lamps are relatively new and don't exactly match those on the balcony.

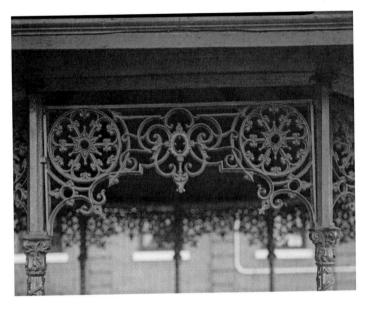

262 MEETING STREET

Gazebos like this 1887 beauty are more often found in gardens. This one by the fire station houses an artesian water fountain.

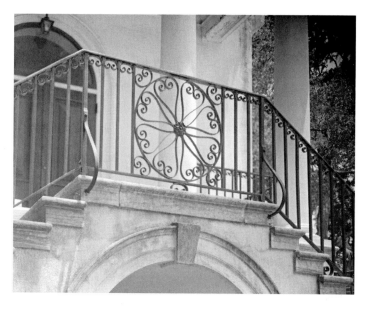

150 MEETING STREET, CIRCULAR CONGREGATIONAL CHURCH
Simple motifs for a small, classical building.

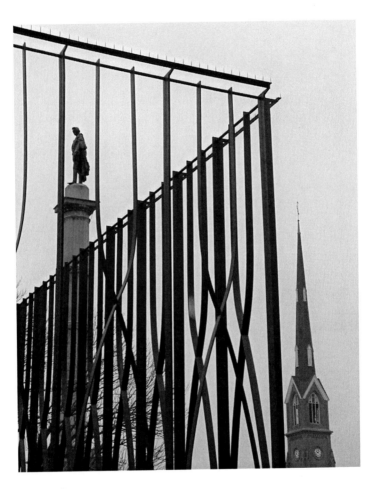

MARION SQUARE
This striking metalwork forms the corner of the Holocaust Memorial. John C. Calhoun is in the background and to the right is a Lutheran church.

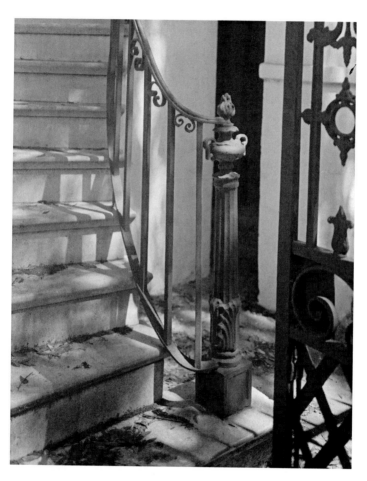

64 MONTAGU STREET
Gate open.

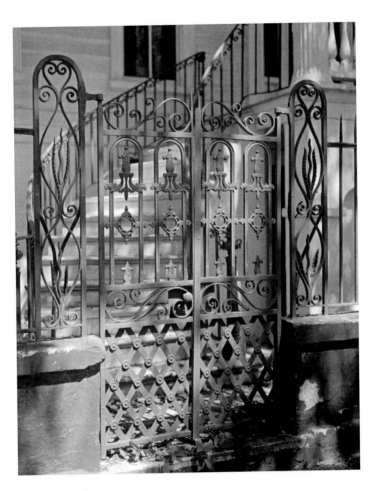

64 MONTAGU STREET
Gate closed.

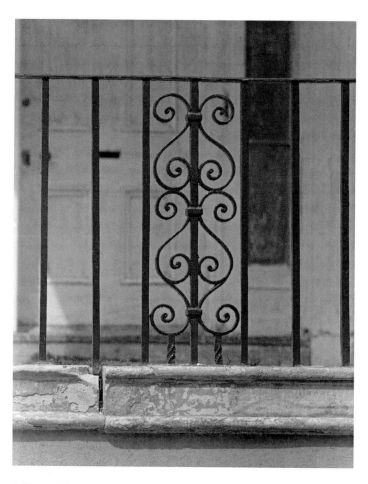

7 ORANGE STREET

A photograph that brings me pleasure. A stretch of stonework that
doesn't quite match up. Colonel Deas dates this one to about 1760.

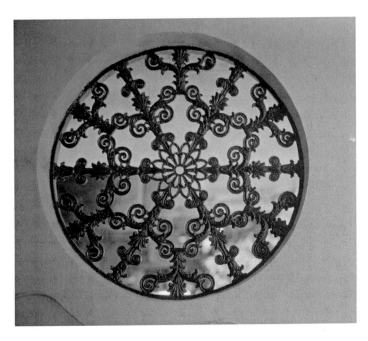

82 QUEEN STREET
Cast-iron grate.

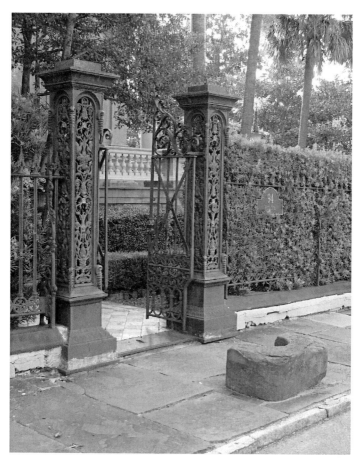

94 RUTLEDGE AVENUE, JENKINS MIKELL HOUSE
In these gateposts, cast iron does the work of masonry. The steppingstone
was for entering a carriage or mounting a horse.

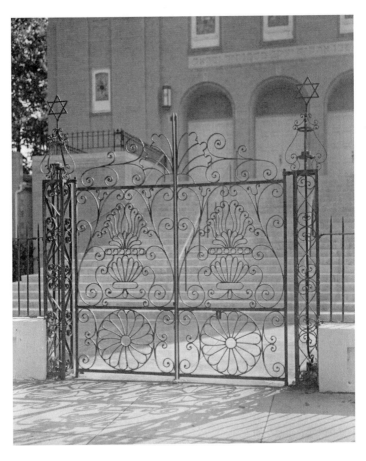

182 Rutledge Avenue, B'rith Sholom Beth Synagogue
Suggestive of St. Michael's gates, but with the devices truncated and
reversed. Circa 1947 by Sabel Iron Works.

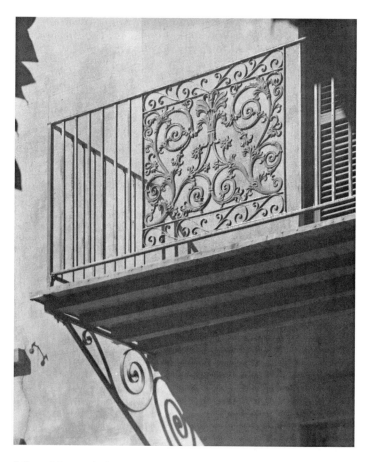

8 SAINT MICHAEL'S ALLEY

The law office of famed anti-secessionist Petigru. Building dates to 1848.

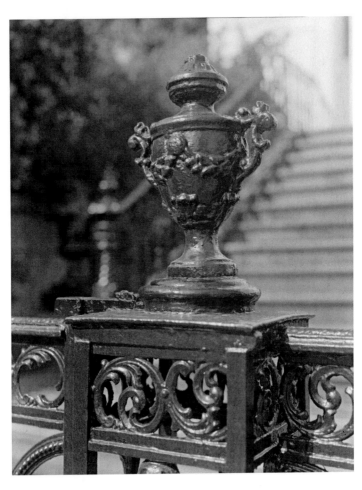

34 Smith Street
This page and opposite:
Iron urns serve as both garden decoration and gatepost crowns.

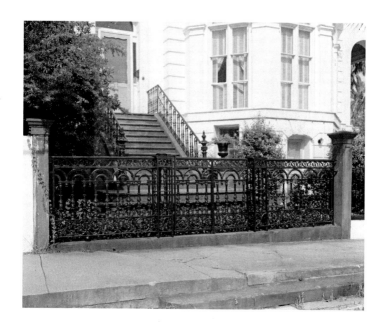

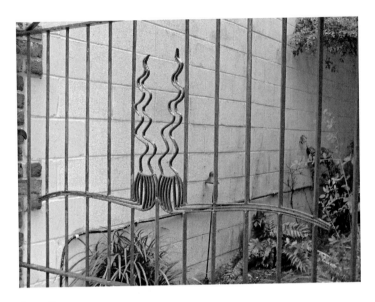

STATE STREET
Slightly out of order. A modern quip on ancient pipes.

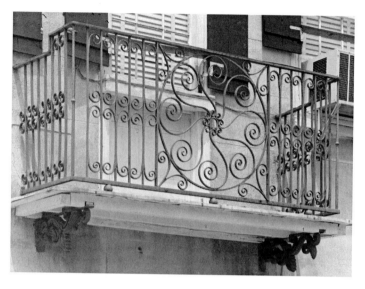

13 STATE STREET
A scrolled, filled balcony with wisteria brackets.

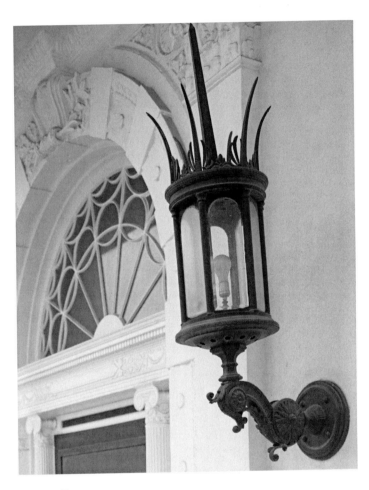

4 SOUTH BATTERY
This is a scaled down version of a medieval lamp.

SOUTH BATTERY

I couldn't resist this contrast between the natural vine and man's opaque version.

20 South Battery

I think this is a Great Blue Heron in a cocktail lounge. Or maybe a Snowy Egret.

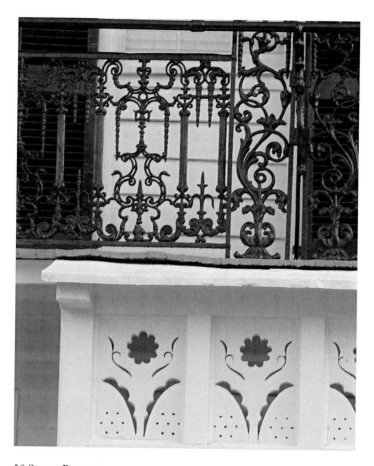

56 South Battery

During the impoverished years following the Civil War, ironwork was sometimes duplicated in less expensive wood. These German Dutch cutouts are a nod in that direction.

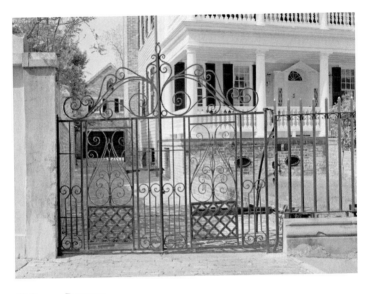

32 SOUTH BATTERY
Carriage gates typical of the neighborhood—typical of much of
Charleston.

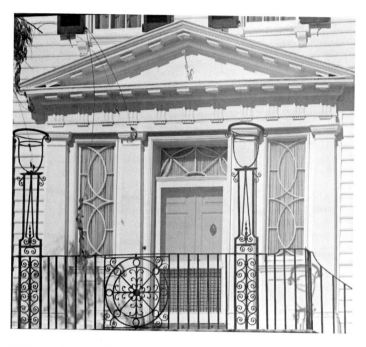

64 SOUTH BATTERY, WILLIAM GIBBES HOUSE

An interesting and ancient collection of iron. The railing dates to the 1772 construction of the house. The lamps and centerpiece were added thirteen years later.

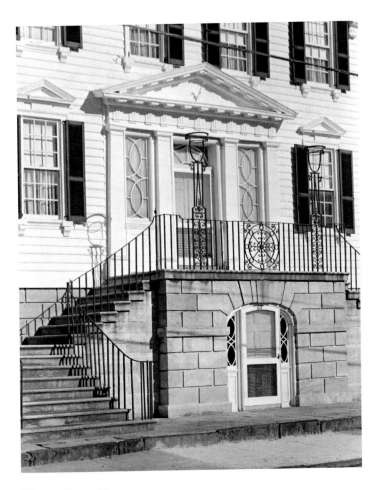

WILLIAM GIBBES HOUSE
A distant view of the same.

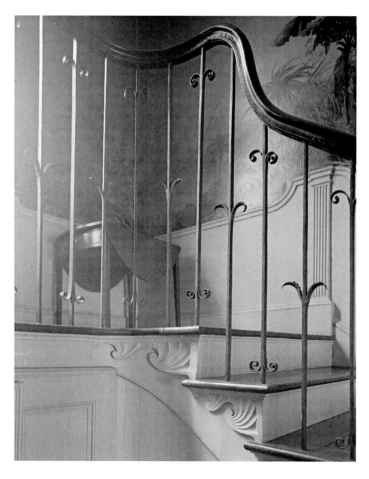

WILLIAM GIBBES HOUSE
Wrought iron for an interior stair is rare in Charleston. Not open to the public.

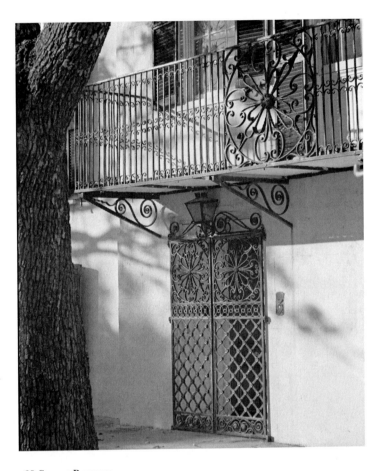

68 SOUTH BATTERY

The design of this central emblem was probably borrowed from the chancel rail at St. Michael's Church. More than half the enjoyment is in the play of shadows.

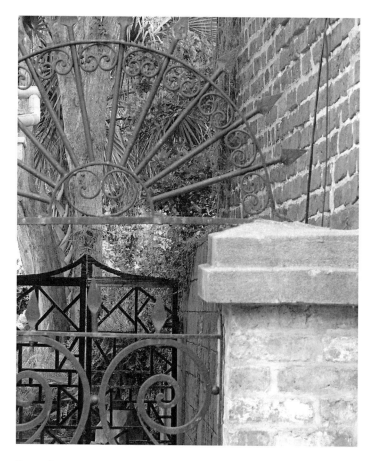

STOLL ALLEY
This is an early piece by Philip Simmons. Already he had begun to work with the earlier Charleston patterns and bend them to his use.

STOLL ALLEY

Another by Philip Simmons. The tightly woven ironwork is necessary because the owner insisted on keeping "the dogs and cats out."

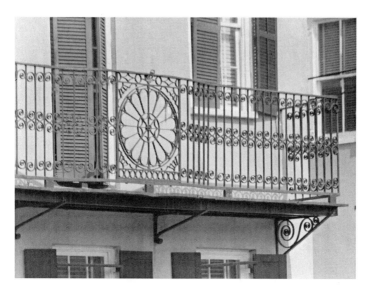

1 TRADD STREET
First balcony.

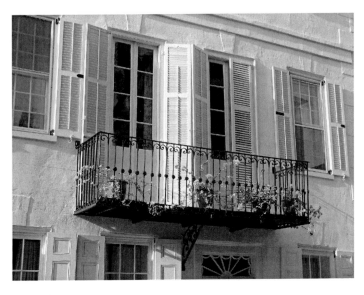

TRADD STREET
Early morning. Note the single bracket beneath the balcony.

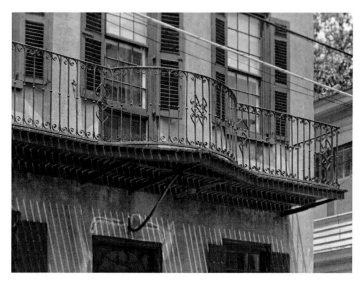

54 Tradd Street

Colonel Deas dates this balcony to shortly before the American
Revolution. Balusters scrolled on either end and beaded at the center.
"The Spanish spindle type of the 18th Century," says Deas.

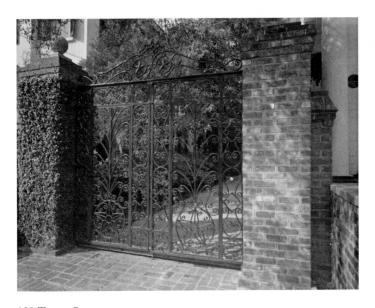

122 TRADD STREET
Wrought-iron carriage gate.

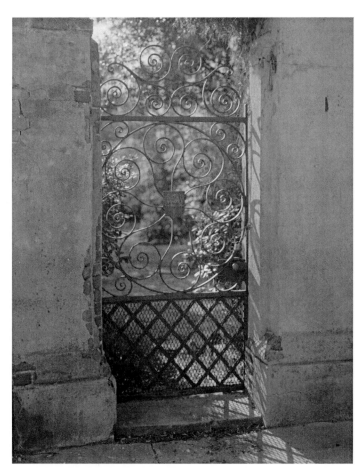

131 TRADD STREET
I included this gate for the garden hinted at beyond.

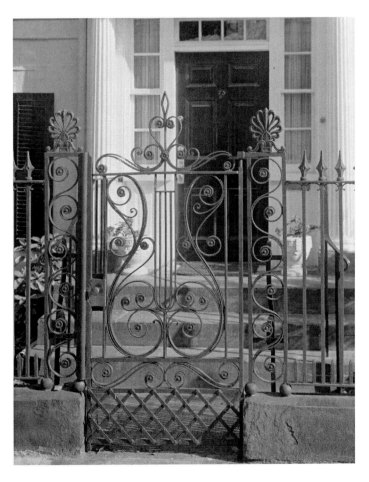

75 TRADD STREET
A familiar lyre and familiar honeysuckles but crisply done.

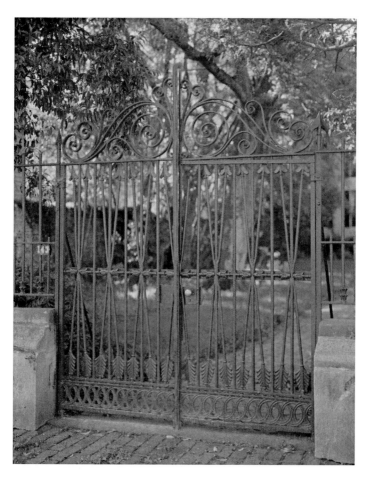

143 Tradd Street
True arrows take the place of pseudo-spears. Rarely done.

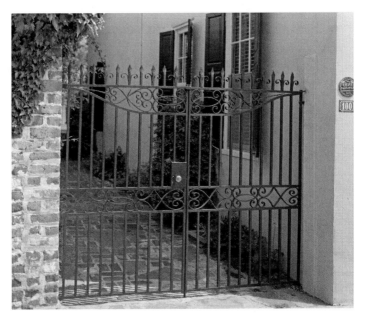

100 TRADD STREET
A Philip Simmons gate based on an earlier and larger Charleston gate.

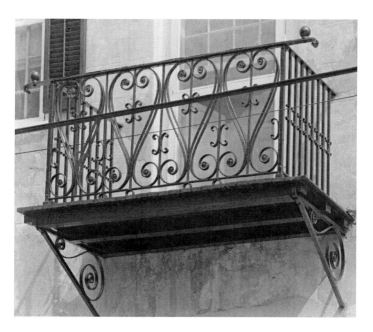

7 TRADD STREET
Familiar lyres.

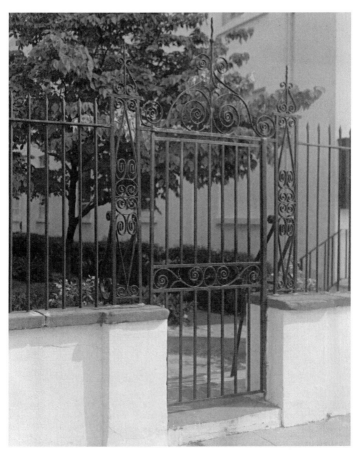

43 Wentworth Street
Again Philip Simmons fashioned a church gate in harmony with those already existing.

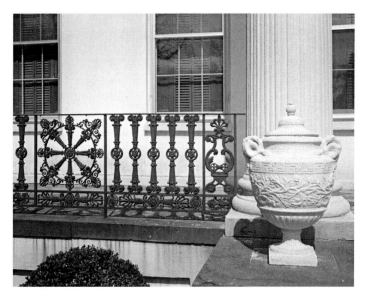

138 WENTWORTH STREET, KERRISON HOUSE
Balustrade of cast iron for this 1840 house.

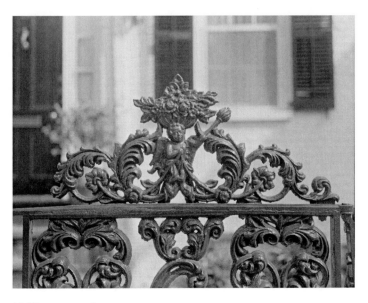

19 Wentworth Street
Torchbearer.

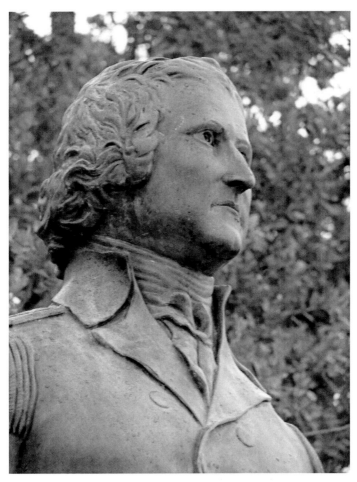

WHITE POINT GARDENS
This statue of General Moultrie is the latest addition to the park.

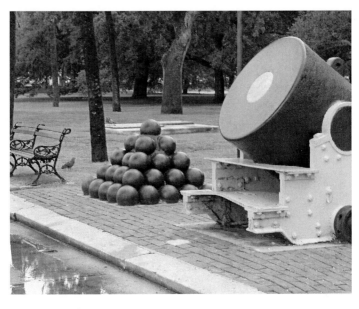

WHITE POINT GARDENS
Something for everyone. Armaments, park bench, pigeons and free parking.

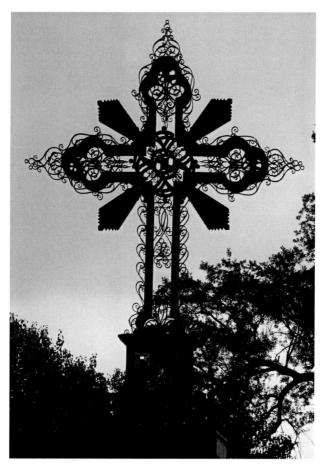

Magnolia Cemetery
This large, iron cross marks the entry to the adjoining Catholic grounds.

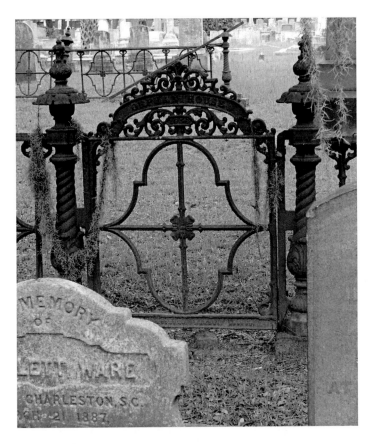

MAGNOLIA CEMETERY

In 1849 Magnolia Cemetery was laid out in the modern park-like manner. The church cemeteries of the inner city had become crowded and were considered a threat to health. Catholic, Jewish and Lutheran cemeteries adjoined it.

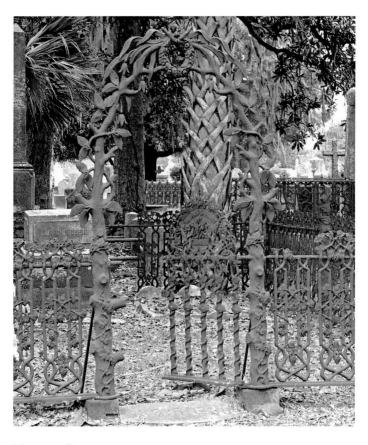

MAGNOLIA CEMETERY
Trees of iron and otherwise. Much of this cast-iron work was ordered
from the catalogues of Philadelphia companies.

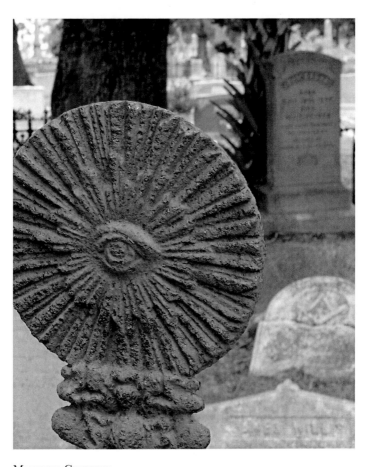

Magnolia Cemetery
The iron eye is the same found on the dollar bill. This is a Masonic plot.
Here the stone is decaying ahead of the iron.

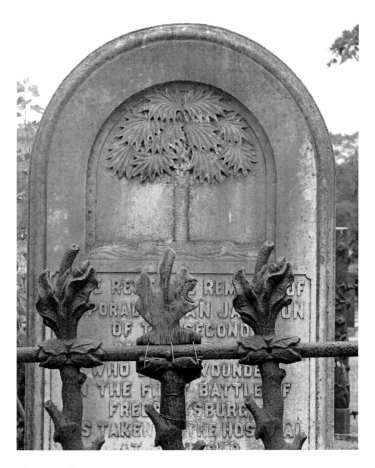

MAGNOLIA CEMETERY
A fine piece of folk art. The crown of this iron oak branch has been
carved out of real oak and wired to the top.

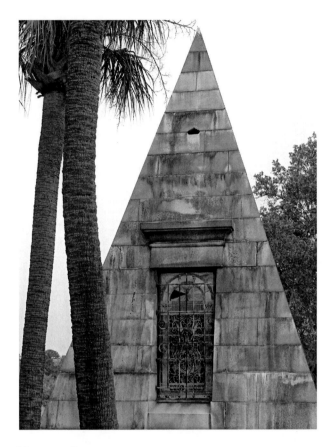

Magnolia Cemetery
As with the iron eye, I suspect this pyramid is another Masonic emblem. It, too, is on the dollar bill. The iron grille protects a stained-glass window that allows light to fall into the center of the mausoleum.

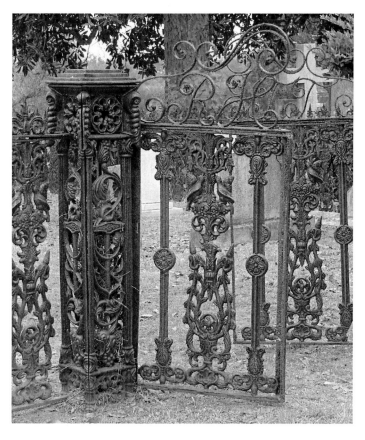

Magnolia Cemetery
One of the more elaborate and better preserved enclosures. The family
initials are incorporated into the gate.

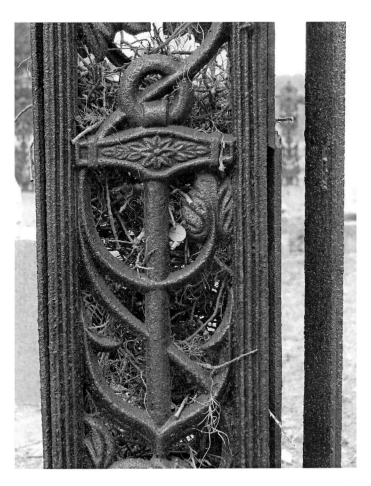

MAGNOLIA CEMETERY
Detail of a Christian symbol with bird nest enclosed.

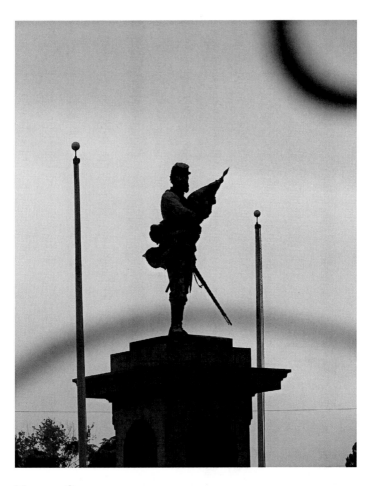

Magnolia Cemetery
The Confederate Memorial viewed through the spiral of a wrought-iron fence.

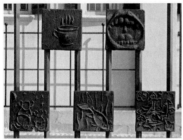

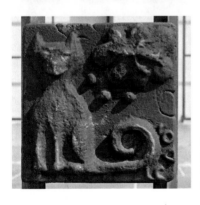

UPPER EAST BAY STREET,
PHILIP SIMMONS PARK
Children did the panels for this
decorative fence.

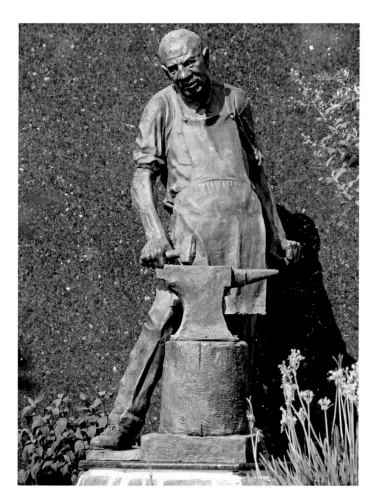

PHILIP SIMMONS PARK
Blacksmith Philip Simmons cast in bronze.

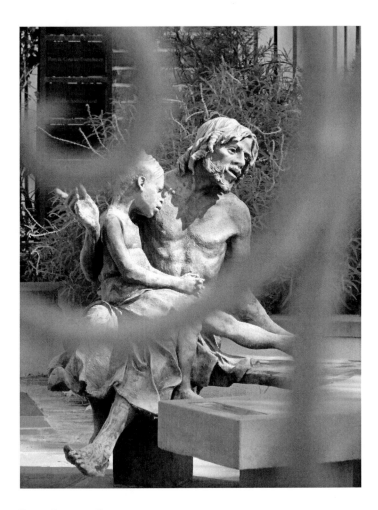

PHILIP SIMMONS PARK
A black Jesus with child viewed through the spiral of a wrought-iron fence.

Selected
Bibliography

Bayless, Charles. *Charleston Ironwork: A Photographic Study*. Orangeburg, SC: Sandlapper Publishing Company, 1986.

Deas, Alston. *The Early Ironwork of Charleston*. Columbia, SC: Bostick & Thornley Publishers, 1941.

Geerlings, Gerald K. *Wrought Iron in Architecture*. New York: Scribners, 1929.

Leland, Isabel. Unpublished Lectures. Leland family.

Poston, Jonathan. *The Buildings of Charleston: A Guide to the City's Architecture*. Columbia: University of South Carolina Press, 1997.

Southworth, Susan, and Michael Southworth. *Ornamental Ironwork: An Illustrated Guide to Its Design, History and Use in American Architecture*. New York: McGraw-Hill Professional Publishing, 1992.

Vlach, John Michael. *Charleston Blacksmith: The Work of Philip Simmons*. Columbia: University of South Carolina Press, 1981.

Visit us at
www.historypress.net